MACRO AND CLOSE-UP PHOTOGRAPHY HANDBOOK

Stan Sholik and Ron Eggers

AMHERST MEDIA, INC. ■ BUFFALO, NY

Acknowledgements:
A special thanks to the staff of Calumet Photographic/Santa Ana,
California for their assistance in providing samples of equipment.

Published by:
Amherst Media, Inc.
P.O. Box 586
Buffalo, N.Y. 14226
Fax: 716-874-4508

Publisher: Craig Alesse
Project Manager: Michelle Perkins
Senior Editor: Frances Hagen Dumenci
Assistant Editor: Matthew A. Kreib

ISBN: 1-58428-026-3
Library of Congress Card Catalog Number: 99-76584

Printed in the United States of America.
10 9 8 7 6 5 4 3 2 1

Notice of Disclaimer: The information contained in this book is based on the authors' experience and opinions. The authors and publisher will not be held liable for the use or misuse of the information in this book.

This book is dedicated to my wife, Linda, and my daughter, Amelia, for their love, patience and support.
— *Stan Sholik*

To Margo, Jennifer, Eric and Sarah, with love.
— *Ron Eggers*

TABLE OF CONTENTS

Pencil Shavings

Introduction

Part of the continuing wonder of photography is in its ability to let us to see the world in new ways. Often that gives us new information and greater insights into the commonplace. Nowhere is this more the case than in the world of close-up and macro photography. Through close-up work, we can discover a world of beauty that few people experience. Not only do we get the opportunity to see the item but, with careful technique and selective vision, we are able to share our view of this miniature world with others.

This book will explore close-up and macro photography with 35mm single lens reflex equipment. The first section covers the equipment required and the techniques used in close-up and macro work. The second details how to apply the equipment and techniques in the field. There are real challenges in discovering appropriate subjects and recording or interpreting them with a minimum amount of equipment. The emphasis is on working in the lower-magnification range using lightweight and easy to use 35mm camera equipment and accessories that can yield high-quality images.

The third section addresses the equipment required and techniques employed for studio close-up and macro work. There, rather than discovering photos, the challenge is in creating them in a controlled environment. Because the studio environment lends itself to a very methodical approach where ultimate image quality is the overriding consideration, this section deals with higher magnifications and more complex 35mm equipment and setups. There's less of an emphasis on automation and more on calculation to obtain desired magnification requirements, lighting setups and exposure values. While the creative process is similar in both cases, the equipment and techniques vary.

Hopefully, nature and outdoor photographers who find the second section of the book interesting and/or useful will try some of the techniques in the third. Similarly, studio and commercial photographers that find the third section beneficial will discover (or rediscover) the world outside the studio.

Before getting down to details, there are certain terms that need to be defined.

What is Close-Up or Macro Photography?

Unfortunately, there is no clear definition as to where an image enters the close-up or macro range. Manufacturers offer

zoom lenses for 35mm cameras with "macro" ranges that do not even permit photography at life-size. So lets define how we will use these terms.

"Close-up" covers the range of magnifications from 1/10 life-size (1/10x magnification or 1:10) to life-size (1x magnification or 1:1). "Macro" will cover the range of magnifications from life-size (1:1) to 40-times life-size (40x magnification or 40:1). However, 10x magnification is the practical limit using 35mm equipment that is readily available on the market.

The term "macro" is actually a misnomer. By definition "macro" simply means large scale, not larger than life-size. The complete term is, more precisely, photomacrography. But this book uses "macro" to stand for photomacrography. Above 40x magnification is the realm of photomicrography, which requires highly specialized compound microscopes.

Since "magnification" is the ratio of the size of the final image to the size of the actual subject, it is independent of the film format in use. By definition:

$$\text{MAGNIFICATION} = \frac{\text{IMAGE SIZE ON FILM}}{\text{ACTUAL SUBJECT SIZE}}$$

When shooting a one-inch tall subject, a 2x (twice life-size) macro photograph of the subject would yield a two-inch tall image on whatever film format is being used. That is, with 35mm film, the entire image will not fit in a single frame, while with 8x10, the image will only cover 1/5 of the height of the frame.

Rather than worrying about magnification, the general approach to a subject is to determine what part of the subject is to be photographed and then to size that area to the film format in use. For the one-inch tall subject then, to capture it on a full 35mm would require a magnification of 1.5x, while in 8x10 the magnification becomes 10x.

Obviously, film format becomes an important consideration when discussing close-up and macro photography. What may be a fairly simple close-up or slightly macro photograph in 35mm becomes a considerably more complex setup in 8x10.

Level of Expertise

Throughout the book, it's assumed that the reader has a good understanding of camera operation and exposure fundamentals, as well as a basic understanding of lighting principles, depth of field and other photographic considerations. The studio section assumes an even greater understanding of photography, as well

as the availability of a good selection of camera and lighting equipment.

There's more to success in close-up and macro photography, though, than a basic understanding of photography. Lack of success generally isn't due to a lack of technical expertise. Rather, it's due to the photographer's inability to adapt to the differences in seeing and composing required for this type of photography, as well as to the need for considerable patience to overcome problems not faced in general photography.

Success in close-up and macro photography is a function of the ability to previsualize a setup and the patience to work to attain that vision. Technical considerations can be learned. Previsualization is a harder skill to acquire. One of the main objectives of this book is to present tools and techniques in the field and in the studio that will allow photographers to capture their vision to their satisfaction.

Chapter One
Equipment Selection

Cameras

While every camera from an Instamatic 110 to 8x10 view has been used for close-up and macro photography, for the overwhelming majority of photographers the 35mm single-lens reflex camera is the optimum choice. It combines versatility and portability with a wide selection of available films, lens and accessories that meet the specialized needs of close-up and macro photographers.

Which camera brand to select is relatively unimportant, given the consistent high quality of modern camera models from manufacturer to manufacturer. But there are features to look for that are important and not available on all models, even from the most popular manufacturers.

These features include through-the-lens metering, mirror lock-up, tripod socket on the camera base, the ability to connect an external cable release (either mechanical or electronic), interchangeable viewing screens and viewfinders, external flash-sync outlet and off-the-film automatic flash exposure control. For optimum results, the tripod socket should be at the bottom of the camera, directly below the lens mount, not offset to one side or the other.

Through-the-lens metering is preferred because, without it, proper exposure in close-up and macro can require complex calculations when using a hand-held external light meter. These calculations will be discussed in detail later in the book. It's sufficient here to point out that an accurate in-camera metering system eliminates most of the calculation requirements by automatically factoring in the increased exposure required in close-up and macro photography.

Although the focal lengths of lenses used for close-up and macro photography are usually within the range of 50 to 200mm, the magnifications involved have the effect of making these lenses seem the equivalent of much longer focal lengths.

As any experienced photographer knows, the greater the focal length, the greater the potential for camera shake. To eliminate the possibility of camera shake, particularly at magnifications greater than 2:1 in ambient light, mount the camera on a tripod, lock up the camera mirror and then use a cable release to trip the shutter.

> "...there are features to look for that are important..."

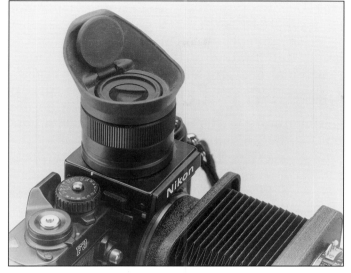

Accessory viewfinders can be a great aid in composing and focusing on close-up and macro subjects, particularly those that like getting close to the ground in the field. Only the right angle viewfinder however can be used with cameras without interchangeable viewfinders.

Left: 6x high-magnification viewfinder provides the most accurate focusing. However, the camera pentaprism must be replaced to utilize the camera's exposure automation.

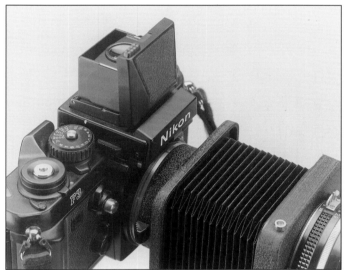

Above: A waist-level viewfinder is another possibility for low-angle photos or to ease focusing. Exposure automation is not possible with this viewfinder either.

Left: A right-angle viewer that attaches to the eyepiece does not provide the ease of focusing of the high-magnification or waist-level viewfinders, but may be the only solution when the camera's pentaprism cannot be removed. It is the best solution for vertical photos since it can be rotated at its base.

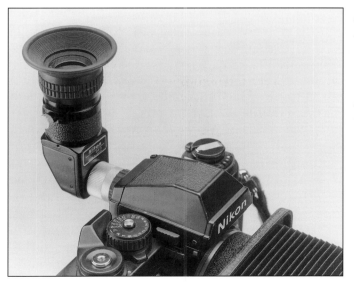

However, locking the mirror up means that the camera cannot be used in any of its autoexposure or autofocus modes. Most current camera models incorporate highly damped mirror mechanisms to minimize vibration resulting from mirror movement, so this is much less of a problem now than it has been in the past.

Tests conducted on the Nikon N90s and F100 (which do not offer mirror lockup) and the F5 (which does) have shown no difference in sharpness at magnifications up to 5x, the limit of the comparison test. An F3, on the other hand, requires mirror lockup at 2x and above. So mirror lockup is currently less of a necessity than in the past for field work, but still highly desirable when working at higher magnification levels.

Many subjects appropriate for macro photography in the field, such as wildflowers, lie very close to the ground. For such subjects it is convenient to be able to replace the camera's pentaprism with a high magnification viewfinder or a waist-level viewfinder. Since these eliminate the ability to meter through the lens, the pentaprism can be interchanged for metering and exposure purposes.

An alternative to replacing the pentaprism completely is the possibility of attaching a right-angle viewer onto the eyepiece of the existing pentaprism. While this adds flexibility to composing the shots, particularly if the composition is a vertical, it does not provide the ease of focusing of the replaceable viewfinders.

Also, it is often desirable to replace the standard focusing screen, particularly if it has split-screen focusing capabilities, with a matte ground glass screen. This makes it possible to focus outside of the central area of the viewfinder. The ground glass screen has a brighter image without blackout if the lens is stopped down to evaluate depth of field.

Photographers who are going to be doing a lot of close-up and macro photography might want to consider focusing screens specifically designed for macro photography. They incorporate very fine matte fields and millimeter grids for measuring image size. They're useful in the field, and almost essential at higher magnifications in the studio.

While subjects can be photographed in the field with ambient light, it's a good idea to have flash available, which can be used as fill or to override the ambient light.

Since the subject will often be very close to the lens, built-in flashes, or accessory flash units attached to a hot shoe on top of the camera pentaprism will not be of much help. They aren't aimed properly to light the subject effectively. The flash must be able to be moved off the camera to properly illuminate the subject.

Advanced cameras will allow remote cords to be attached between the camera accessory shoe and the remote flash, providing full through-the-lens flash automation. Like through-the-lens metering, off-camera auto-flash controls simplify exposure,

"Also, it is often desirable to replace the standard focusing screen."

letting photographers concentrate on aesthetics rather than the technical aspects of the photograph.

When working in the studio, a PC-outlet is essential for connecting external power packs controlling studio flash units. As an alternative, if the camera only has a hotshoe, low-cost accessory units are available that slide into the hotshoe and provide the necessary PC cable connection.

Finally, autofocus is unnecessary. In fact, it's not recommended at all. With close-up and macro photography, selecting the point of focus of the subject being photographed involves both aesthetic and technical considerations that shouldn't be trusted to the camera. While modern autofocus cameras provide many of the desirable features for this type of photography, the autofocus feature itself should be turned off and the lens adjusted manually.

My personal camera choice for many years has been the Nikon F3. It provides all the desirable features as well as being exceptionally rugged and reliable.

Recently, I have experimented with the Nikon N90s and F100. These camera bodies fall somewhat short on some accounts, but their off-the-film flash automation systems are far superior to that of the F3. With the introduction of the F5, Nikon has addressed the minor N90s (and F100) shortcomings (lack of mirror lockup and lack of replaceable pentaprism) and is an excellent choice for both field and studio work. However, where automated flash fill or automated multiple strobes are not required, the F3 remains a perfect choice and is my first choice for studio work. Other camera brands, including Canon and Minolta, are marketing equipment with similar capabilities that deserve consideration.

On the digital side, few of the more affordable consumer-oriented digital cameras have close-up and macro capabilities built in, but manufacturers have begun to address this limitation and to make close-up attachments for popular models available. While the image quality of these affordable models doesn't begin to rival film-based cameras, the instant gratification of having an image immediately available gives them a lot of appeal.

Unfortunately, consumer-oriented digital cameras generally do not support through-the lens viewing. LCDs do, but LCD screens are difficult to use in bright light, and the low contrast of the imaging CCD limits their usefulness in other situations.

As technology advances, affordable digital cameras will become a more realistic alternative for close-up and macro work. Higher-end digital cameras based on popular 35mm camera bodies are a potential alternative for close-up and macro photographers interested in having digital images immediately available. These digitals, however, are very expensive, from $5,000 to $20,000 and more. Still, cost is less of a consideration when previously purchased equipment will be usable on the digital camera.

It's important to remember that while the lenses may be interchangeable and other equipment can be used with both film and

> "...autofocus is unnecessary."

digital bodies, many of the digital cameras have CCDs that capture the electronic images in a smaller format than the 35mm film format. This effectively changes the magnification of a lens between when it's used on a 35mm film camera and when it's being used on a digital camera designed to be integrated into a 35mm system.

As prices for these higher-end digital cameras decrease and their resolutions increase, they will become more important for the close-up and macro photography. Photographers will be able to make a smooth transition to the new cameras, utilizing the experience and techniques learned with film-based systems.

Lenses

As mentioned, just because a lens is marked as a "**macro**" does not mean that it is designed or even suitable for close-up and macro photography. That's particularly the case for most so-called "macro zooms," multi-focal-length lenses that supposedly have "macro" capability.

This capability is often limited to one focal length only (the shortest) and is usually limited to magnifications of about 1/4 life size. The image quality produced by these lenses varies considerably by brand and model. While they might work for casual close-up work, for the most part they are unsuitable for serious work.

There are several ways to achieve true close-focusing and macro capabilities with 35mm cameras. These include: supplementary (close-up) lenses; reversing rings; extension tubes; bellows; and true macro lenses.

Close-up Lenses

Supplementary lens attachments offer the quickest, easiest and least expensive entry into the close-up world. Widely available in sizes to attach to the front of nearly any lens, they come in a range of strengths, from 0 to 10, the higher numbers indicating greater magnifications. They increase the focal length of the lens.

The strength of these lenses is measured in diopters, a "diopter" being the reciprocal of the close-up lens' focal length in meters (1/focal length). Thus a +1 diopter lens has a focal length of 1 meter or 1000mm, a +2 diopter lens the focal length of 1/2=0.5 meter or 500mm, etc.

A diopter acts like a magnifying glass when placed in front of a lens that's focused at its infinity setting. The lens-to-subject distance of closest focus is equal to the focal length of the diopter. A +1 diopter lens fitted to any lens focused at infinity will be able to focus on an object 1000mm or about 39.5 inches away. Any object further than that cannot be brought into focus, but objects nearer can be brought into focus up to a minimum distance determined by the lens.

> "There are several ways to achieve true close-focusing and macro capabilities with 35mm cameras."

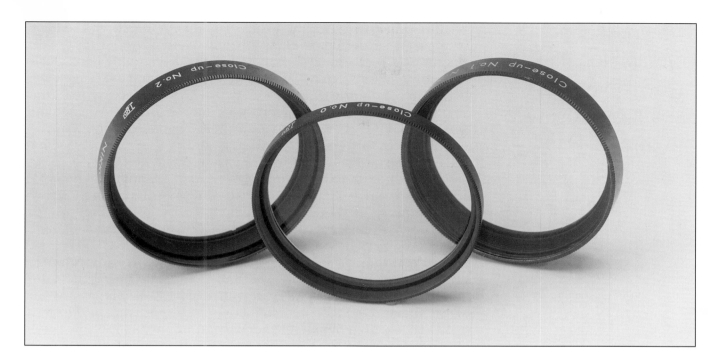

Above: Supplementary close-up lenses can be attached to the filter thread of any lens to allow close focusing. They are available in several strengths, usually denoted "0,1 and 2." The higher the number, the closer the lens can be focused and therefore the higher the magnification.

The focal length of the camera lens determines the field size (magnification) when the supplementary lens is attached. For example, a 100mm lens fitted with a +1 diopter close-up lens and a 50mm lens fitted with a +1 diopter close-up lens will both be able to focus on an object 39.5 inches away. However, the object will be twice as large with the 100mm lens.

In theory, supplementary close-up lenses placed very close to the elements of the camera lens will yield image quality results equal to the quality possible from the camera lens alone. This being the case, the higher the quality of the camera lens, the better the results after attaching the close-up lens.

In practice, even the highest quality diopters introduce some aberrations that can effect the quality of the images. Those aberrations increase with the focal length, the aperture of the lens and the strength of the diopter. Stopping the camera lens down to an aperture of $f/11$ or $f/16$ will reduce those aberrations, but doesn't necessarily eliminate them.

Close-up lenses themselves vary widely, so considerable care should be taken to buy quality lenses. Some manufacturers sell multi-element close-up lenses. They carry higher price tags, but they can be worth the investment. There are a number of things that should be kept in mind when selecting close- up lenses. One is that the numeric designation that manufacturers put on them is not necessarily the diopter value. The designation number/diopter value varies with manufacturers. With Nikon, a No. 0 close-up adapter is a +0.7 diopter, a No. 1 is +1.5 and a No. 2 is +3.0.

It is possible to use close-up lenses in combination, but there is some reduction in image quality. Again, that can be minimized

"When used in combination, the higher power lens should be closest to the camera lens."

by stopping down the lens. When used in combination, the higher power lens should be closest to the camera lens. A +1 diopter in combination with a +2 diopter will yield the equivalent close-focusing capability of a +3 diopter, but the image quality is better when the +3 diopter is used alone.

Two high-quality supplementary lenses of low to medium power used in combination will yield very good results. If necessary, three adapters can be used together, but it's not recommended. There's an unavoidable loss of quality.

Depth of field with supplementary lenses is minimal, varying from approximately 9 inches with a +1 diopter to 1.0 inches with a +3 diopter when attached to a 50mm lens set at f/8 and focused on infinity. At closer focusing ranges and with longer focal-length lenses, the depth of field is even less.

Table 1 shows the maximum focusing distance for common supplementary close-up lenses and combinations of them for prime lenses to which they are attached. Also shown are the approximate field size, magnification and approximate depth of field at f/8 with a 50mm lens focused at infinity.

It's a good idea for any photographer to carry a set of supplementary close-up lenses in the camera bag. They're easy to use, require no exposure compensation and they leave the automatic metering and autofocus fully functional, while being relatively inexpensive.

While they're a good idea for most photographers, supplementary close-up lenses are an essential tool for any photographer interested in close-up and macro photography.

Table 1: Supplementary Close-up Lenses

Close-up lens Diopter Strength	Lens-to-Subject Distance (inches)	Approximate Field Size (inches)	Magnification	Approximate Depth of Field at f/8 (inches)
+1	39.5	18 x 27	0.05x	9
+2	19.5	9 x 13.5	0.1x	2.5
+3	13	6 x 9	0.15x	1
+4	10.875	4.5 x 6.75	0.2x	0.5
+5	7.875	3.625 x 5.375	0.25x	0.375
+6	6.5	3 x 4.5	0.3x	0.25

Lens-to-subject distance applies to any focal length lens.
Field size and reproduction ratio apply to 50mm lens focused at infinity.

Right: Supplementary close-up lenses offer the quickest, easiest and least expensive entry into the close-up world. When using them, no exposure compensation is required.

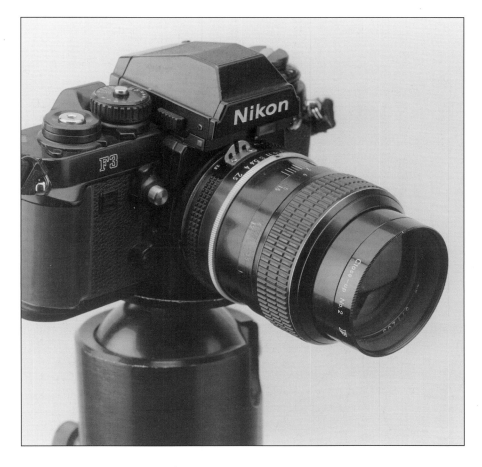

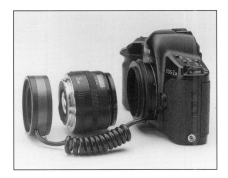

Above: The lens reversing system made by Novoflex for Canon EOS cameras and lenses provides full exposure automation as well protection for the rear of the lens when it is reversed. Adapter rings may be required between the lens and the camera to match thread sizes.

Reversing Ring

A simple and inexpensive means of entering the close-up world is through the use of a lens reversing ring. This is a thin metal ring that screws into the front of the lens as a filter would, but it has a mount on the other side that attaches to the camera body. Costing about as much as a set of supplementary close-up lenses, a lens reversing ring yields excellent quality results when used with high-quality normal, moderate wide angle and moderate telephoto lenses.

The disadvantages of these rings, however, limit their usefulness. Magnification is limited to one setting, depending upon the focal length of the lens. Additionally, both the lens-to-subject distance and focusing range are limited. Another problem is that the rear element of the lens is exposed, leaving delicate electrical contacts and the back lens surface vulnerable to damage. Also, it is impossible to attach a lens hood to limit flare.

Finally, with most reversing rings, through-the-lens metering is only possible in stop-down mode, if that mode is supported by the camera. Attaching extension tubes or a bellows between the camera and the reversing ring eliminates some of these disadvantages and is an alternative when very high magnifications are desired, like in studio photography.

Right: A lens reversing ring mounts between the camera body and the lens, allowing the lens to be reversed so that the rear of the lens faces the subject. This offers another inexpensive means of achieving close-up images without exposure compensation. However, most automatic cameras will not provide exposure automation with the lens reversed.

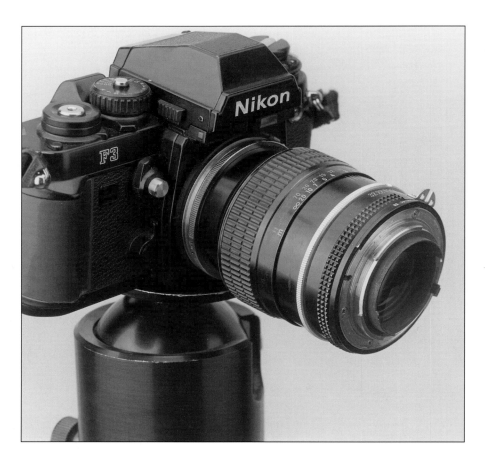

Tele-converters and Extension Tubes

Tele-converters and extension tubes can also be used for close-up photography. However, tele-converters, generally sold as accessories for telephoto lenses to increase their power, are limited in usefulness.

Commonly available in powers of 1.4x and 2x, they multiply the focal length of the camera lens by 1.4 and 2 times respectively. For close-up work, they can be used to photograph subjects that are 1.4 or 2 times larger at the minimum focusing distance of the lens, without having to move in closer to the subject. They preserve both working distance and infinity focus. Another advantage is that, in most cases, they also preserve all or most of the camera's automatic functions.

The disadvantages of tele-converters are (1) a light loss of 1 stop for 1.4x and 2 stops for 2x tele-converters, and (2) cost. A high quality converter can easily cost as much as the lens itself.

Extension tubes, on the other hand, are inexpensive cylinders of metal in several lengths that can be stacked together to provide close-focusing capability. They are attached on one side to the camera body and on the other to the lens to extend the distance between the two.

It is possible to use extension tubes with any lens to permit closer focusing, although, once again, infinity focus is lost. Some

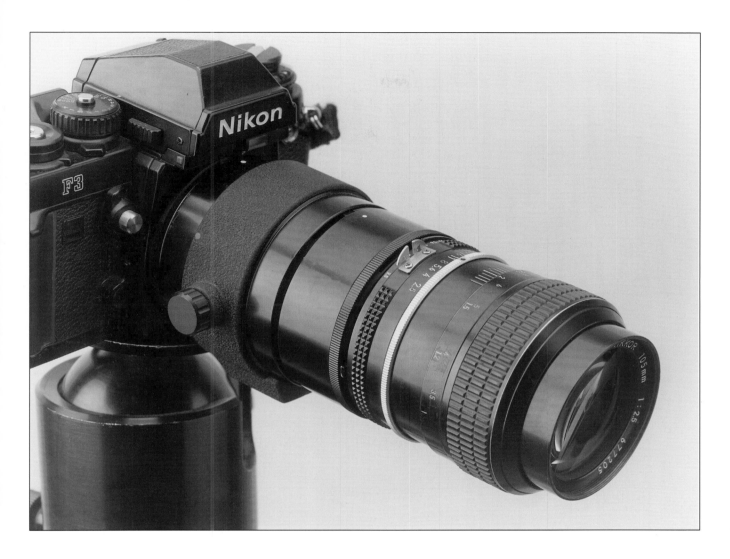

Above: Extension tubes are also positioned between the camera body and lens, providing magnification by extending the lens from the camera. Here two extension tubes are stacked together. Exposure compensation is required when extension tubes are used.

"macro" lenses are supplied with an extension ring that has to be attached to achieve 1:1 magnification.

With extension tubes, the exposure setting needs to be increased due to the increased distance between lens and camera body. With older extension tubes, autoexposure won't work. Newer extension tubes provide for full autoexposure functionality, but, in most cases, not autofocus capabilities.

The disadvantage of extension tubes is that they only permit specific magnification steps. Often the optimum composition, particularly at higher magnifications, falls somewhere between those steps. That disadvantage can be overcome by the use of a bellows between the lens and camera body.

Macro Lenses

Unlike the "macro-zooms," which provide marginal results, there are specialty "macro" lenses available. While they still can't go beyond 1:1 magnification for true macro capabilities, they provide excellent results. They are the optimum solution for close-up

photography. A macro lens is probably the first accessory a photographer interested in shooting quality close-up work should acquire.

There's an extensive selection of macro lenses on the market, including various models from major camera makers and third-party manufacturers.

Macro lenses are optimized by design for maximum image quality in the close-up and near-macro range. Most modern macros provide continuous focusing from infinity to 1:1 magnification while preserving all the automated features of the camera being used.

Macro lenses are most commonly available in two focal ranges: a "normal" version in the 50-60mm range, and a "telephoto" version that has a 90-105mm focal length. Some manufacturers also offer a "long-telephoto" 200mm version.

Of the three, the "telephoto" is the most valuable for field work since it provides twice the lens-to-subject distance of the "normal" while offering the same maximum aperture (usually ƒ/2.8). For studio work, where it is usually used in conjunction with a bellows unit, the "normal" lens is more appropriate.

While there are autofocus macro lenses available, it's a better idea to go with a manual model. In general, autofocus macros have a distinct disadvantage, in that when they are used in a vertical or nearly vertical orientation, the looseness of the focusing mechanism required for the autofocus to work causes the lens to frequently creep out of focus.

Since focusing is one of the most important controls involved in close-up photography, it is not a control that should be delegated

Right: Lenses designed for use in the close-up and macro range provide the highest quality images. All provide continuous focusing from infinity to the close-up range, though some require extension tubes to reach 1:1. Shown from left to right are focal lengths of 105mm (with extension ring), 200mm, and 55mm (with extension ring). The greater the focal length of the lens, the greater the working distance from lens to subject at a given magnification.

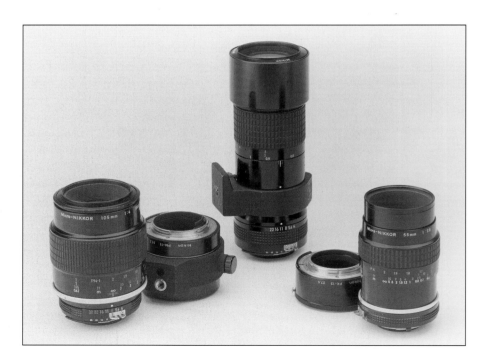

to the camera, even with the sophisticated autofocus systems available today. Manual-focusing macro lenses may sacrifice total exposure automation for the security of focus stability.

Bellows

Bellows units are capable of providing a continuous range of magnifications from approximately 1:1 to 10:1 depending on the lens being used, whether it is attached normally or in a reversed position, and the physical length of the bellows. Some bellows units can be joined together, providing higher magnification levels from longer focal length lenses.

The highest magnifications are achieved using the shortest focal length lenses (20mm) available, mounted in reverse on the bellows. With this configuration, there is less than 1.5 inches of working distance between the front of the lens and the subject at the maximum magnification of 11x. The Nikon PB-6 bellows, for instance, provides continuous magnification from 4.5x to 11x when used with a 20mm lens in reverse position.

Image quality with bellows can vary considerably depending on the lens being used. With some lenses, image quality improves as the lens is stopped down; with others, image quality is best at an in-between setting. On the 55mm Micro Nikkor, image quality is best at $f/8$. It's good to experiment with different lenses on the bellows to determine which lenses provide what range of magnification and at what point the image quality of each lens begins to deteriorate.

Inexpensive bellows units consist of the expandable bellows portion supported on a single track. The camera is mounted to one end of the bellows and the lens to the other. A better choice is the doubletrack bellows, which provides a separate track, called a focusing stage, below the bellows proper. With this type of bellows, magnification can be set by calculating the bellows draw required for the lens' focal length, and the entire camera/bellows/lens system moved forward and back on the lower rail for focusing.

When selecting a bellows unit, be sure that it allows the camera to be easily rotated from horizontal to vertical. A motor drive isn't required (or even recommended) for close-up and macro photography. However, some cameras appropriate for this work have them built-in, so be sure that the camera's motor drive or winder does not interfere with the bellows' operation.

Bellows units are not particularly well suited for field use, not only because of their bulk and the fragile nature of the bellows itself but also because of the loss, in nearly all cases, of full exposure automation.

When it is available with a bellows at all, automatic exposure control usually involves "stop-down" metering. In other words, the lens aperture has to be set manually before the exposure can

"Image quality with bellows can vary considerably depending on the lens being used."

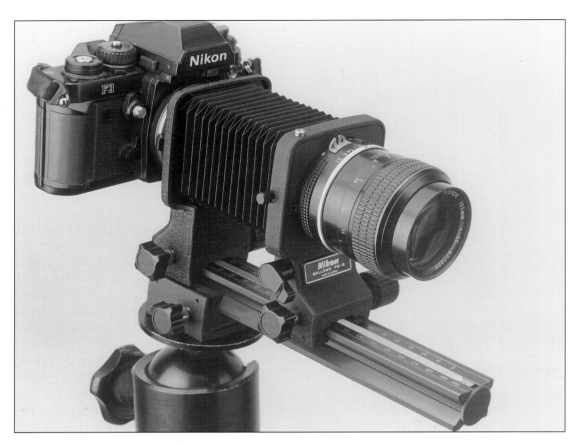

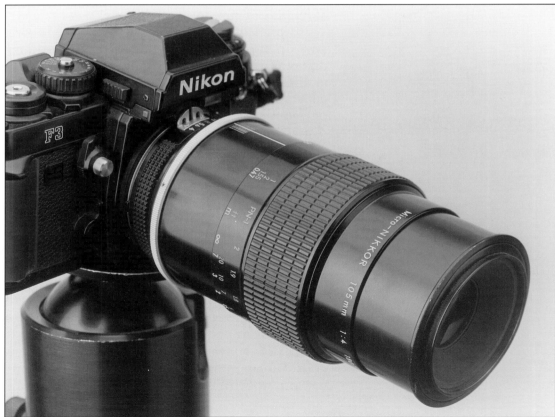

Opposite page, top: Bellows units function like extension tubes by increasing the distance from the lens to the camera body, but they provide a continuous range of magnifications rather than discrete steps. Magnifications of 1:1 to 10:1 are possible depending on the lens used. Exposure compensation is required in increasing amounts as the bellows is extended.

Opposite page, bottom: A lens optimized for close-up photography is the optimum solution. In conjunction with close-up lenses, extension tubes or bellows units, its use can be extended into the macro range. While exposure compensation is required at magnifications greater than 1:10, most lenses of this type will couple with the camera's automatic exposure functions so manual compensation is not required.

"After buying the macro lens, the next purchase might be an automated fill flash..."

be metered. In the field, that means critically focusing the camera with the lens wide open, stopping the lens down for metering (thereby making the viewfinder dark), then trying to maintain focus and composition as wind, air currents and other uncontrolled factors move or shake the highly magnified subject. At best, that's an extremely frustrating experience. Nevertheless, bellows offer versatility that's unmatched by any other close-up and macro photography accessory. Bellows are the equipment of choice for high-magnification work in the studio.

Lighting

Lighting is the single most important ingredient in a successful close-up and macro photograph. Whether working with ambient light in the field or creating a complete lighting environment in the studio, the ability to control light to achieve the desired creative effect is an essential technique that must be mastered.

There are numerous lighting and light-control options available, from simple fill cards to expensive studio flash systems. Matching the equipment to the photo at hand is another of the many challenges for close-up and macro photographers.

Automated cameras provide close-up and macro field photographers working alone with a great tool — through the lens flash exposure automation. Only a relatively inexpensive low-guide number unit is required, since it will be used very close to the subject, hand-held and connected by a remote cord to provide automated flash control. This sometimes winds up resulting in one-handed camera operation, but that's still more convenient than trying to work with, position and hold fill cards.

After buying the macro lens, the next purchase might be an automated fill flash and an automatic flash coupling cord. The photo on page 24 shows the system I take with me as a minimum whenever I shoot in the field and often use for quick photos in the studio, which might best be referred to as the "simple system."

There are options available that go beyond the simple system. One solution that extends lighting capabilities is shown in the top photo on page 25. Such a combination provides full control over main and fill lighting while still providing the full range of flash exposure control available with the camera. That approach can be used for field work or in the studio. For complicated shots, it's possible to mount the flash units on individual table-top tripods or lighting stands for studio work, as shown in the bottom photo on page 25.

In the studio, the photographer has complete control over lighting. One critical decision that has to be made is selecting the right lighting equipment. This is essential to create a successful image. There are two general types of lighting equipment available, tungsten and electronic flash, with extensive light modifying accessories available for each type.

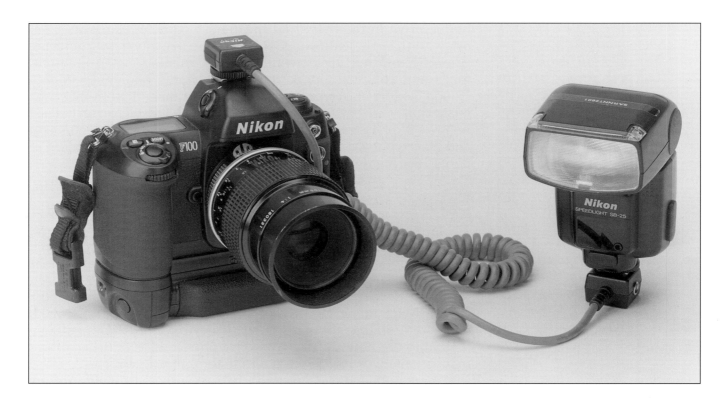

Above: The combination of an automatic camera and off-camera automated flash is ideal for location close-up and macro photography and quick photos in the studio. Throughout the book, this system is referred to as the "simple system."

Opposite page: Full control over main and fill lighting is provided by the combination of an automatic camera and two off-camera automated flash units. The flash units can be coupled to the camera and to each other with special connecting cords (or slave units) which preserve flash exposure automation. The top photo shows the system configured for field or studio use with connecting cords. The bottom photo shows the system as it could be used in the studio with the flash units on mini-tripods, with the flash unit to the right triggered by a remote flash slave unit.

Tungsten Lighting

Tungsten lights provide a bright, continuous light source for close-up and macro photography. Clear photoflood bulbs of 250 or 500 watts, as well as quartz halogen lamps, are all tungsten. All tungsten light sources are rated with a color temperature of 3200° K (Kelvin). For proper color balance without a filter, they require Type B, either transparency or negative films. It's also possible to use Kodachrome Type A film, but that requires using an 80 color correction filter.

Quartz halogen fixtures are a better choice than tungsten. Their bulbs produce a more consistent color temperature throughout their considerably longer life, and there are more size, type and wattage choices available. On the down side, they are considerably more expensive than photofloods. The advantage of both types of continuous light sources is their brightness, the fact that "what you see is what you get," and their ability to be measured by a conventional hand-held light meter or by the camera's built-in meter. No specialized flash meter is required.

Continuous light sources are also known as "hot lights" and that can be a problem — both photofloods and quartz halogen lights generate considerable amounts of heat when in use. They are also generally quite large, therefore making them difficult to position for close-up shots of small subjects and limiting their usefulness to larger, inanimate objects. They are, however, ideal for copy work where bright, even lighting is essential. They also come in handy as a focusing aid, even when the light source used for taking the picture will be electronic flash.

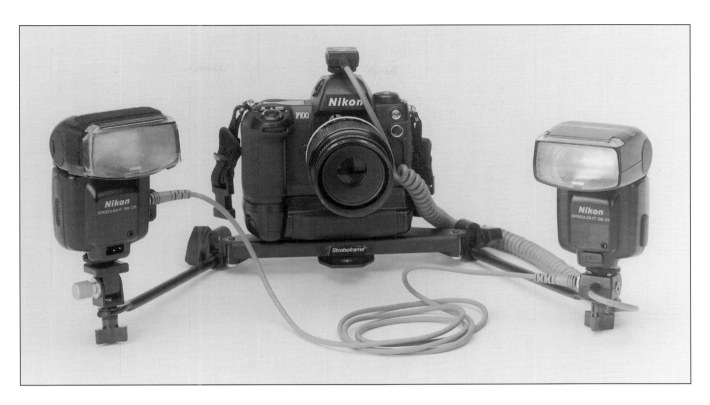

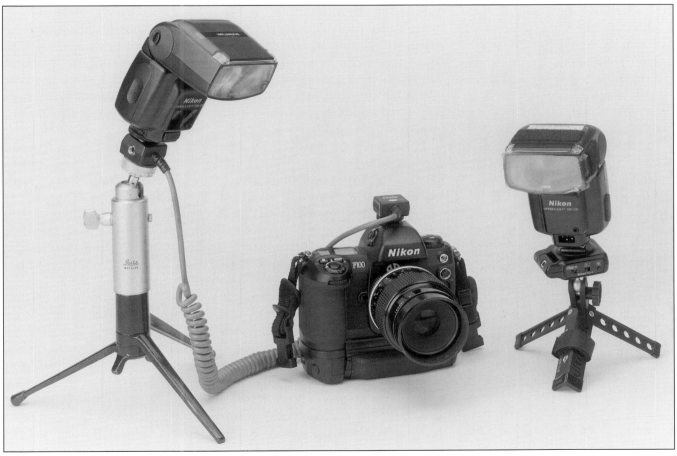

"Electronic flash is the best lighting source..."

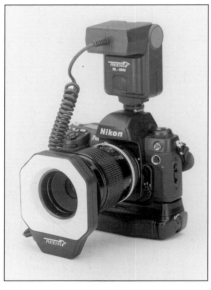

Above: A ring light provides even illumination for subjects very close to the lens. The unit shown, available for numerous camera models, makes full use of the camera's built-in flash automation to provide correct exposure at close-up and macro magnifications.

Electronic Flash

Electronic flash (or strobe) is the best lighting source for close-up and macro photography in the studio. Small, battery-powered units tied to off-the-film automatic flash metering simplify exposure. AC-powered studio strobe units are available from a number of manufacturers.

More expensive units overcome the biggest disadvantage of the automatic models — they provide a built-in modeling light to preview the effect of the flash. Both types of flash unit have the added advantage of firing for a very short duration, thus minimizing the possibility that vibration will cause unsharp images.

Small battery-powered flash units need to be moved off the camera accessory shoe to be used effectively. Most camera manufacturers market an accessory cable that allows continued automated flash capabilities.

When a non-automatic bellows is used, the cable still provides a triggering signal for the flash. Additional units that provide fill light, background light, accent light, etc. can be added and synched with appropriate cables and sensors.

Many accessories are available to modify the light from flash units. Diffusers or reflectors are made to effectively increase the size of the light source, while small white, silver or gold reflectors are available to bounce some of the light back into the shadow side of the subject.

Commercially available products work well enough, but many items can be custom designed and produced by the photographer. They can be custom-sized for the subject at hand. White, silver or gold board is available from art supply houses, and heavy cardboard can be covered with aluminum foil. Small pieces of reflective materials are available at camera or movie supply houses.

Hobby shops as well as camera supply stores are a good source for small clamps and flexible arms to hold these reflectors in exactly the position required. These light modifiers work equally well with AC-powered strobes.

AC-powered strobes most often consist of flash heads connected by cables to capacitor/control units, although some strobes are self-contained with the controls and capacitors in the flash heads. Others have the capacitors in the flash heads and only the controls in a separate unit.

There are also very inexpensive strobes available that can be screwed directly into light sockets. These strobes are tripped by built-in slaves. They are very effective but relatively low power.

Any flash set-up works, but the smaller and lighter the head, the more versatile it is for close-up and macro studio photography. Units with power ratings of 400 watt-seconds are sufficient for studio close-up and macro photography with 35mm cameras.

There are considerably more options available for AC-powered flash units. They accept a wide range of light modifiers from

Below: AC-powered studio flash units accept a wide variety of accessories to modify their light output. Shown here are a standard reflector with and without a diffuser, grid spots to concentrate the light into beams of 10, 20, 30 or 40 degrees, a small light box to provide a large diffuse source for close-up subjects and a barn-door attachment that can also hold colored or neutral-density filters.

a variety of manufacturers, including reflectors of varying angles, grids for spotlight effects, light boxes of varying sizes and configurations, colored filter holders, and the like. (See photo below.)

The biggest advantage of these AC-powered strobes comes from the built-in tungsten or quartz-halogen modeling light which provides a more-or-less accurate simulation of the effect of the flashtube. At the same time, the modeling light provides sufficient illumination for focusing, at least at low-to-medium magnification.

One unusual accessory available from several manufacturers of AC-powered strobes (and one small battery strobe manufacturer) is fiber-optic cabling. Because of their small diameter, about 0.5 inch, fiber optics can be used to light very small objects by positioning them very close to the subject.

They can also be used to create special lighting effects on larger objects. Fiber optic cables consist of multiple strands of specially manufactured glass fiber that conduct light from a light source at one end to illuminated objects at the other end, with minimal loss of light (as illustrated on page 29).

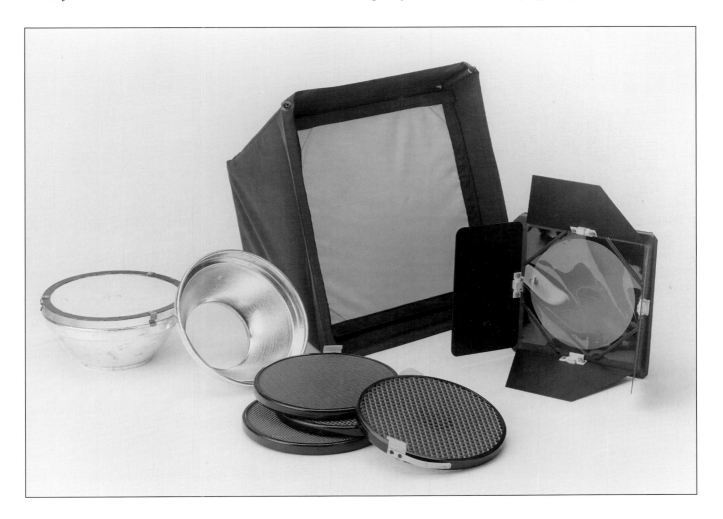

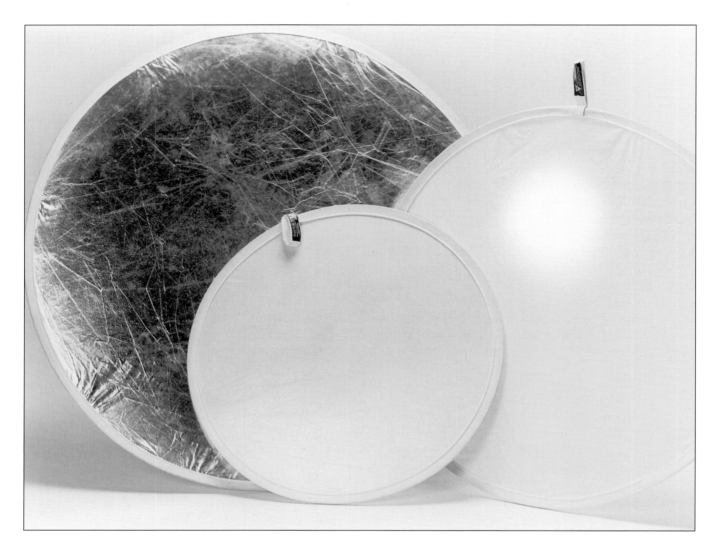

Above: Commercially available reflectors and diffusers are useful accessories both in the field and in the studio. Available in a variety of sizes, they fold into compact discs for carrying. Shown here, left to right, are a large silver reflector, a small white reflector and a medium-size white diffuser with a light shining through to show the degree of diffusion. Varying degrees of diffusion are available as well as other reflecting surfaces.

The greatest advantage of fiber optics is in the ability to put a relatively large amount of light into a relatively small area, while taking up very little space themselves.

With only 1.5 inches of lens-to-subject distance at 11x magnification from a 20mm lens reversed at the full extension of the bellows, fiber optics may be the only way to provide illumination. The functionality of fiber optics cable can be expanded through the many accessories available, such as focusing lenses, diffusion and gel holders, focusing spotlights, and iris diaphragms.

Another light source that might come in handy is the AC- or battery-powered ringlight. Mounted on an adapter ring that's positioned to the front of the lens, it is capable of providing even illumination to close-up and macro subjects. Some ringlights are single light units. Others consist of separate flashtubes in either two or four positions around the ring, making it possible to separately adjust power settings.

My theory of lighting is that it should simulate to a reasonable degree the lighting of the natural world. I have yet to experience

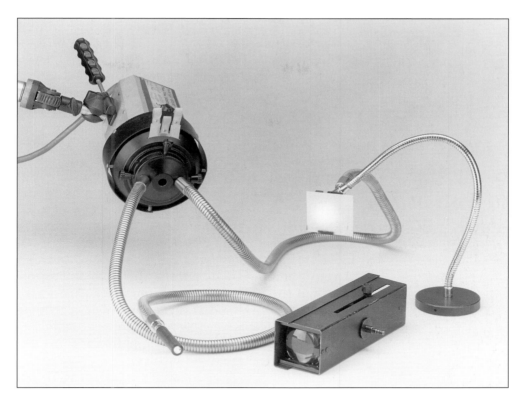

In the studio, fiber-optic lighting accessories for strobe power packs allow large amounts of light to be concentrated into very small areas with no heat, making them ideal for high-magnification macro photos. They are designed to accept a wide range of accessories including diffusers, focusing lenses, snoots, etc. The photo above shows part of the Balcar flash system. The bottom photo shows a similar system from Broncolor.

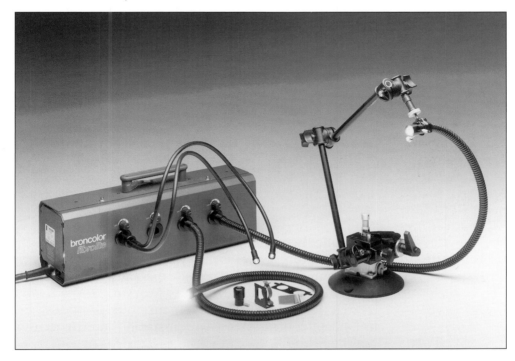

light emanating from a circle around my head and providing the only illumination of a scene, so I have found little use for a ringlight other than a fool-proof way of making quick photos of small dull-surfaced objects such as postage stamps.

Exposure Meters

When automated exposure is unusable, a hand-held flash or ambient-light meter must be used as a first step in determining exposure. Any quality meter is applicable, but there are some that are better suited for macro photography than others. Some manufacturers, for example, provide accessory probes specifically designed for macro metering. There are also some that can read both ambient light and electronic flash.

Incident light metering is the most accurate way to determine light requirements. It measures the light falling on the subject rather than the light reflected from it.

At reduced working distances, however, a reflected light spotmeter may be necessary. Several meters available can be used both as incident and spot meters, with appropriate accessories. These provide the most versatility.

> ## "When automated exposure is unusable, a hand-held flash or ambient-light meter must be used…"

Right: Exposure meters are useful accessories and can be essential when the camera's automated exposure system is unusable. From left to right, the photo shows various types of meters: a continuous light meter with incident dome; a combination continuous light/flash meter with incident dome; a combination continuous light/ flash meter with accessory 5-degree spot meter attachment; a continuous light meter with flat disc diffuser for metering 2-dimensional subjects, and a combination continuous light/ flash meter for metering 1-degree reflected light.

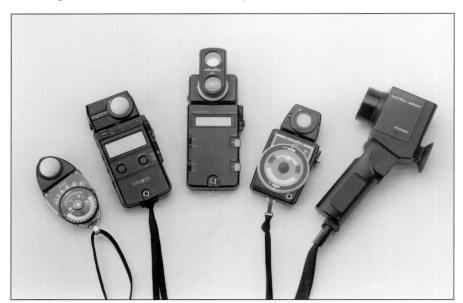

Tripods

While the mobility of the "simple system" makes it very handy, there are times in close-up photography when a sturdy shooting platform is required. This is especially true when working in the macro range of magnifications. Working with a tripod puts severe restrictions on your movement, but provides, even requires, fuller concentration on composition than the more mobile handheld method.

Right: Choosing a tripod is as personal a choice as choosing a camera. Here, a typical field tripod (left) and studio tripod (right) are shown. While both provide sturdy platforms, the field tripod is smaller and lighter with a short center column so it can be adjusted close to the ground. It is also equipped with a quick-release ball head. The studio tripod features a crank-up center column (making small vertical adjustments more convenient) and a platform head. It is also has a quick-release plate.

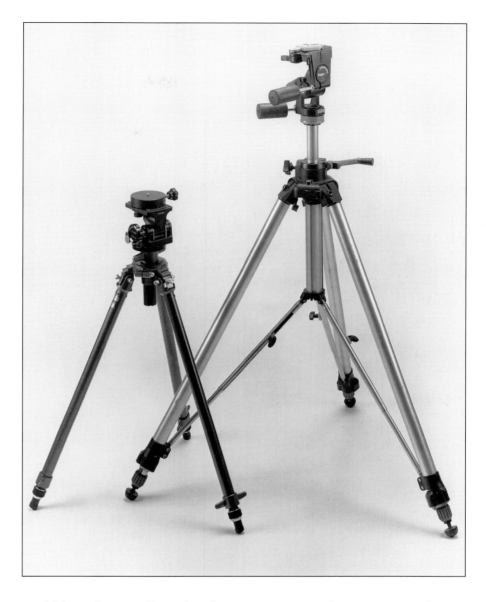

"Tripods present another of the many dilemmas facing the close-up and macro photographer..."

Although a quality tripod can cost as much as or more than a macro lens, close-up and macro photographers should have one available. Serious close-up and macro photographers will have one for field and another for studio work.

Tripods present another of the many dilemmas facing the close-up and macro photographer in the field: stability requires a heavy unit, but carrying one around on the chance that it might be used doesn't seem practical. Further complicating the issue is the fact that most subjects are close to the ground, and most tripods aren't specifically designed with that in mind.

There is a relatively simple solution to the weight vs. stability question, and most field photographers go in that direction. That is, you can purchase a high-quality but medium weight unit and hang additional weight on it for added stability. The simplest form for the additional weight is the photographer's camera bag.

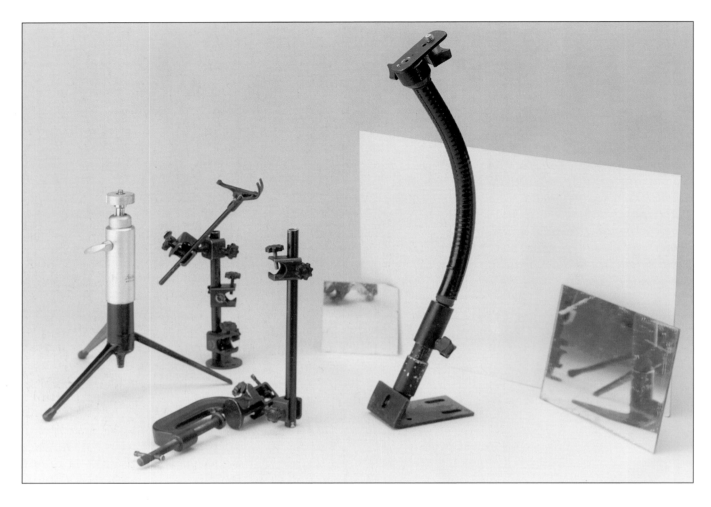

Above: Helpful accessories for close-up and macro photography in the studio range from table-top tripods to clamps, arms and stands from the hardware store. Small plastic mirrors that can be cut to size as well as white cardboard reflectors are also useful. Camera stores stock many items, but most can be found or fashioned for much less than they can be purchased.

It adds weight, and it's a good way to keep the bag off the ground while shooting.

Finding a tripod that reaches six to twelve inches off the ground while providing the ease of adjustment required in close-up and macro photography is not as easy a problem to solve. A reversing center column is a less-than-ideal solution, although nearly any configuration is going to put the camera controls into some unusual position.

Some tripods, including the very popular Gitzo, allow the center column to be removed completely and replaced by a short column or a flat plate, and the legs can be spread almost completely horizontal. Although the minute center-column adjustments that are possible with the center bar are lost, it still works very well.

Also available from Gitzo and other manufacturers are extension arms that can be attached to the camera plate, center post or the tripod leg for field work. Selecting tripods tends to be as personal a selection for many photographers as choosing a camera body. It's based as much on feel as on practical considerations.

A sturdy tripod is even more essential for studio work. A lighter-weight unit can be made more stable by hanging additional weight

from it as mentioned above, but there's no substitute for a heavy-duty unit. In the studio, where added weight works to the photographer's advantage, it's better to go with a model that has a crank-up center column rather than a manually raised column. That makes small vertical adjustments possible.

Small table-top tripods are also useful accessories for studio work. They can provide a mounting platform for holding flash heads or even the subject. Adjustable gooseneck arms with a heavy base are useful for the same reasons. Hobby stores stock various clamps, arms and stands that can hold subjects, reflectors and mirrors to make life easier for the close-up and macro photographer in the studio or the field.

Ball Heads/Platform Heads/Quick-Releases

Choosing a tripod head is as personal as choosing a tripod. Proponents of ball heads and platform heads make compelling arguments, but the choice ultimately comes down to what works best for each photographer.

Ball heads offer quick adjustment in all planes by means of a single control. They also form a very compact package, without adjusting arms sticking out in several directions. However, pound-for-pound, they will not support the same amount of weight without slippage as platform heads. And, if adjustment is required in only one plane, a ball head is much less efficient since, once the head is loosened, all planes must be reset.

Platform heads, on the other hand, allow for small adjustments in separate planes, but are larger and bulkier—though slightly lighter to carry and use. Which way to go is determined by the photographer's own preferences and working style.

Whether selecting a ball or platform head, a quick-release plate is recommended. A quick-release system consists of two

> "Small table-top tripods are also useful accessories for studio work."

Ball heads are less bulky than more conventional platform tripod heads, making them ideal for field work. On the left is a lightweight but sturdy Cambo model that would require a separate quick-release plate. To the right is a heavier-duty Cambo model with a built-in quick-release plate (camera attaching plate not shown). In the center is a unique design, no longer available, that functions like a ball head but contains no ball, and features a panoramic head on the camera plate. A plain camera plate is also shown.

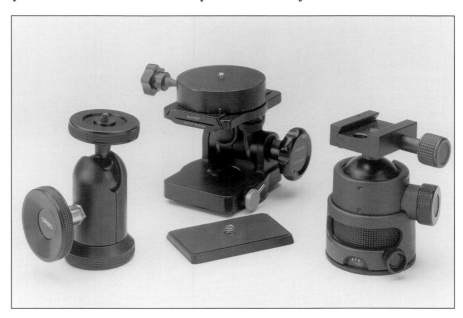

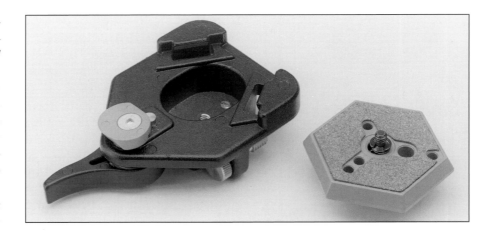

Quick-release systems are available from a number of manufacturers. Some are built into ball heads and platform heads. Others, like the model shown from Bogen, can be attached to any head. All types consist of two sections. One section, shown here on the right, attaches to the baseplate of the camera, while the other attaches to the tripod. The lever on this section clamps the camera plate in place. When locked together, there should be no play in the units.

plates, one attached to the camera's tripod socket and the other attached to the tripod head (though some ball heads have permanent mounts built into them). The two plates slide together and are locked by a lever. The larger the surface areas of the plates and the tighter they fit together before locking determine the quality, stability and cost of the system. There should be absolutely no play in the two plates when they're locked together.

Since much of the preliminary work in composing the subject is done with the camera being handheld, then attached to the tripod head as a late step before final adjustments are made, the quick-release platform greatly simplifies the attachment of the camera. Extra plates can be carried for additional bodies.

In the next section, we will see how to put the equipment discussed above to work.

Chapter Two
Photographic Considerations

Now that camera and lighting gear has been selected, its time to put it to practical use. Suitable subjects can be found anywhere. For shooting in the field, there's the whole range of the natural world such as flowers, plants, insects, and aquatic life. And there are the man-made objects also, anything from weathered wood structures to peeling paint on old metal signs.

Many of these subjects can be brought into the studio for higher-magnification photos. Jewelry, coins, feathers, semi-precious stones and minerals are also fascinating subjects in the studio. Even common household items like sponges, crayons and pencil shavings, or various food items such as walnuts, become appealing subjects for the close-up and macro photographer.

Once the subject and composition of the macro photograph has been determined, the first equipment decision should be the selection of the appropriate focal length lens and accessories (close-up lens, extension tube, bellows etc.) necessary to achieve the required magnification.

Generally, select the longest focal length lens available for the magnification of the composition being shot. This guarantees the greatest working distance from lens to subject, since both the subject-to-lens distance and the lens-to-film distance increase with increasing focal length.

While foreshortening caused by close working distance is not usually a problem, even in macro photography, the greater working distance allows less intrusion when dealing with live subjects and more room for fill cards or supplemental lighting.

With shorter focal length lenses, increased working distance as well as increased magnification can be achieved by using a reversing ring. But, as noted, that comes at the expense of automatic lens operation and automated exposure control.

If there are several lenses available that would do the job (with or without accessories) to achieve the intended magnification, one important consideration is the amount of background desired in the photo. With the same subject magnification, a longer focal length lens will take in less background than a lens with a shorter focal length.

For example, a 100mm macro lens will take in only 1/2 the amount of background as a 50mm lens at the same magnification. At the same time, the 100mm lens allows you to be twice as far from the subject, which can be important when photographing live specimens.

"...the first equipment decision should be the selection of the appropriate focal length lens..."

There's the common misconception that depth of field is greater with a short focal length lens than with one of longer focal length. Since depth of field is always minimal in close-up and macro photography, it would seem that the first choice would be a wide-angle lens. However, it can be proven mathematically that depth of field for all practical purposes is dependent only on the final magnification and the lens aperture, not the focal length. So depth-of-field considerations do not affect into lens selection.

Another common misunderstanding regarding depth of field that is relevant to close-up and macro photography is the way in which depth of field is distributed. While in general photography it is commonly accepted and generally accurate that depth of field extends 1/3 before and 2/3 behind the point of focus, this ratio does not hold true at close focusing distances. Rather, depth of field as the magnification approaches 1:1 becomes more evenly split, 1/2 before and 1/2 beyond the point of focus.

Since depth of field is so shallow in any case with close-up subjects, it's important to focus accurately in the center or just slightly before the midpoint of the depth limits rather than 1/3 of the way in. Focusing slightly before the midpoint provides an increased illusion of sharpness since the brain finds out-of-focus blurs less distracting in the background than in the foreground.

Focusing itself becomes difficult in close-up and macro work. This is partially a result of the light loss (2 stops at 1:1) but also a result of the distances of the subject to the lens, the subject to the film and the lens to the film. These effects are particularly apparent at 1:1 magnification, where minor adjustments in focus can necessitate major changes in lens-to-subject distance.

The proper method for focusing at very close-up distances involves setting the approximate magnification on the macro lens or lens-bellows combination (with or without the use of close-up lenses or extension tubes), then moving the entire system forward or back to achieve focus. Once focus is attained, if the magnification is not exact, it can be changed and the process repeated until the intended results are achieved. When shooting hand-held, rocking the body slightly forwards and backwards achieves precise focusing at the desired magnification. When working with a tripod for higher-magnification images or slower shutter speeds, this technique is simplified by the use of a focusing stage mounted between the camera and the tripod, as shown on page 37.

Once the approximate magnification is set on the lens, the focusing stage moves the entire system forward or backward at the set magnification to adjust focus. Again, adjustment can be made to the magnification as required for the composition, and the focusing stage can be adjusted until the final image is composed and focused. It's best to move the camera for focusing; however, the subject can be moved slightly when all else fails.

"Focusing itself becomes difficult in close-up and macro work."

Right: A focusing stage greatly simplifies the process of achieving sharp focus when the camera is mounted on a tripod. If the focusing ring on the lens is rotated even slightly, the magnification changes and the tripod must be moved forward or back to adjust. With the camera mounted on a focusing stage, magnification is set on the lens and the tripod moved into approximate position. Final focus is achieved by moving the camera forward or back along the focusing rail. If the magnification needs to be adjusted, moving the camera along the focusing rail will readjust the focus while the tripod remains untouched.

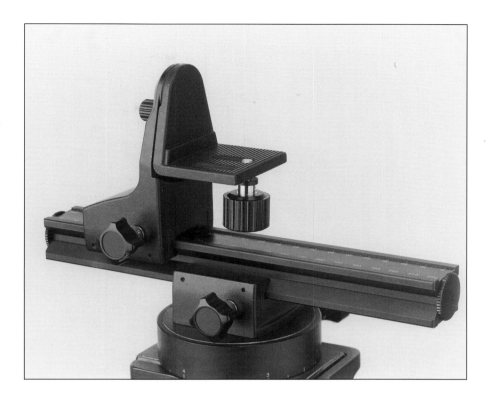

Where to focus is as important as how. It has a direct impact on the success or failure of the photograph being taken. In close-up and macro photography even more so than in general photography, the eye is drawn to either the brightest area of the subject, or, if all values are similar, to the area of greatest contrast either in value (dark vs. light) or color. Rendering such areas in sharp focus is essential.

Where the subject is outlined in relief against a brighter background, focusing on the edge of the subject is generally the best solution. However, if the bright background area is larger than the foreground subject, the image may still not look right, since the background will dominate. That's one reason why many of the most successful close-up and macro photographs are taken with a dark or black background: so that there will be no hint of competition between the subject and its surroundings.

With a lot of luck, this effect will occur naturally. When it does not, it can be achieved artificially with black cloth or by auxiliary lighting. To understand how to do this, one must understand the basics of lighting and how an image is captured on film.

Lighting Principles

With automatic exposure control available in newer electronic cameras, it isn't necessary to calculate exposure manually in many situations. However, it is important to understand how to achieve proper exposure in close-up and macro photography, just as it is in general photography. That's important for those times when it

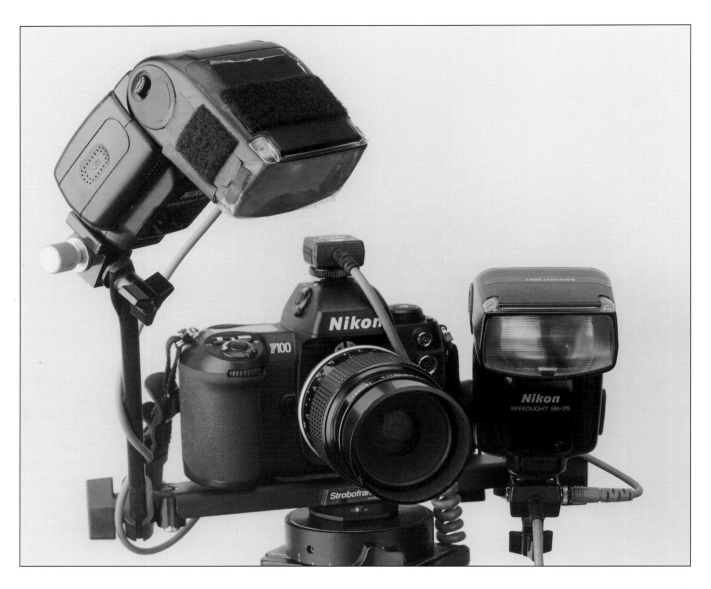

Above: The best rendering of structure and detail of three-dimensional subjects will occur when the main light is positioned 45 degrees above and to the side of the subject and the fill light is positioned close to the camera lens. The fill light should be set at a lower power setting than the main light.

is desirable to exert creative control over exposure by turning off the camera's autoexposure and setting the controls manually.

To understand exposure, it is necessary to understand lighting principles in general. Every image recorded on film contains three basic areas of exposure: highlights; mid-tones; and shadows. The proper relationship of these three areas determines the correct exposure relative to the film's latitude (its ability to record the full range of exposure) and the photographer's previsualization of the final image.

For scientific purposes, which requires as objective a record shot as possible and where full detail is important, it is necessary to generate an image containing primarily midtone values. That provides the greatest amount of information about the subject. But, for creative interpretations, images frequently contain primarily shadow or highlight areas. That might mean large

amounts of shadow area, as in strongly backlit scenes or high key areas with little detail.

Whether trying to capture an objective record shot or a subjective interpretation, achieving the desired result requires a thorough understanding of lighting and exposure principles.

Highlight areas are the parts of a composition that are bright, but still retain at least some small amount of detail. They differ from 'specular highlights' such as the reflection of the sun in a drop of water or off a shiny metallic surface where no detail can be rendered. On initial viewing, the eye is always drawn to highlight areas in a photograph, so where they exist, they should be rendered in sharpest focus.

At the opposite end of the exposure range are the shadow areas, where the idea again is to retain some detail. They differ from the "deep shadows" in the scene, which contain no detail and are recorded at the maximum density (D-max) of the film in use.

Between the shadows and the highlights are the 'mid-tones' where most of the information on the film normally falls. It is the range of values in the midtones that provides information about the subject's color and structure.

Close-up and macro photographs are often tight compositions of mid-tone areas of the subject under ambient light conditions, making them relatively easy for in-camera exposure meters to handle. But they can be flat and uninteresting to view. They lack "contrast," which is the difference between the brightest and darkest areas of the image. Achieving proper exposure of these midtones (where desired) while including (or creating) highlight and shadow areas to add contrast to the photograph is one of the greatest challenges to the close-up and macro photographer.

The range of image contrast that a film can capture is known as the film's "latitude." Modern color transparency films have a latitude of at least five *f*-stops from highlight to shadow, and color negative films have even more.

The idea is to utilize as much of this latitude as possible. That will produce the most image content, though that may not necessarily be the most dramatic image. Two of the most important factors effecting the contrast range of the scene are the size and direction of the light source illuminating the subject and the subject's inherent contrast.

In general photography, shooting on location during midday on a sunny day should be avoided. The over-head sun creates excessive contrast. It, in effect, serves as an intense and small, albeit distant, light source. It's a better idea to shoot in the early morning and late afternoon hours, when the sun is closer to the horizon and the open sky lowers the contrast of a scene.

In close-up and macro photography, the same principle holds: the smaller the light source in relation to the subject, the greater the contrast, although the scale is vastly different. The angle of the light to the subject also has a profound effect on the contrast.

"It is the range of values...that provides information about the subject's color and structure."

"A considerably larger light source controls contrast, but then detail suffers."

In general, a light source approximately the same size as the subject to be photographed provides the best match between detail rendition and contrast control. That's as true in close-up and macro photography as it is in general photography. A light source considerably smaller than the subject will enhance detail but increase contrast. The sun is, in effect, a very small light source.

That's why, for example, close-up photographs of peeling paint in full sunlight can be so effective, with saturated colors and deep, hard-edged shadows that enhance the detail of the paint. In this situation, the excessive contrast between the paint highlights and the black shadows are what give the photograph its impact.

A considerably larger light source controls contrast, but then detail suffers. Understanding the relationship between light source and the resulting detail and contrast makes it easier for a photographer to capture exactly what was intended to be captured, rather than depending on luck.

A photographer has complete control over close-up and macro lighting both in the field and in the studio with a flash system like the one shown in the top photo on page 25. There are flash units on articulating arms on either side of the camera. In general photography, these flash units are small in relation to the subject, and therefore provide a high contrast light.

It's different with close-up and macro photography where the lights approximate the size of the subject. They may even be somewhat larger than the subject size. That makes it possible for them to control contrast and optimize detail. When used in conjunction with automated off-the-film flash, the system provides a consistent, accurate and fully controllable light source.

Using this system, both light output and direction are completely under the control of the photographer. Even affordable flash units of moderate power have enough output to give apertures of $f/11$ at close-up distances, while more powerful units allow $f/22$ or smaller.

Optimum lighting ratios can be achieved since the light output of one unit in relation to the other can be adjusted either on the units themselves or by adding neutral density filters to the unit designated as 'fill'. By controlling light ratios, the photographer can make full use of the latitude of the film while at the same time controlling subject contrast. Diffusion filters can also be added to the fill light to eliminate the possibility of cross shadows.

Shutter speeds of 1/60 of a second or higher, depending on camera model, will darken the background, while the short flash duration eliminates the problem of minor camera or subject movement.

The two articulating arms of the system allow the 'main' light to be positioned in the ideal location for rendering structure and detail of three-dimensional subjects: 45 degrees above the

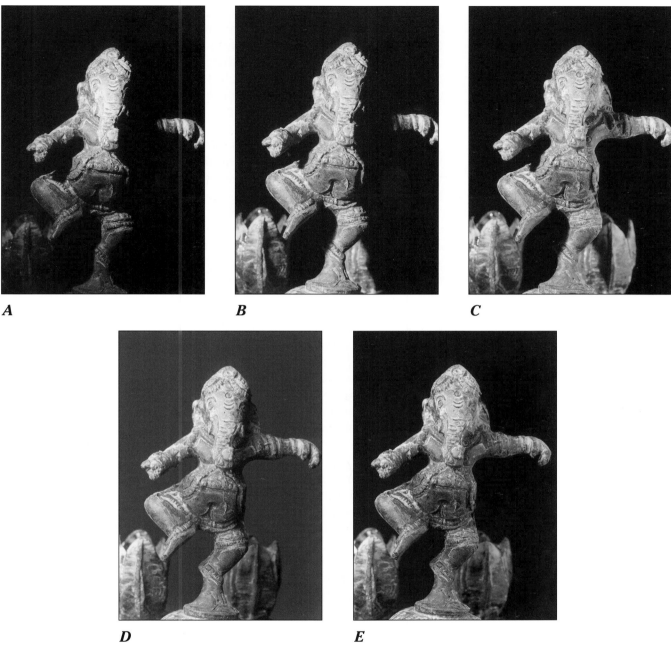

A B C

D E

Above: The size of the light source determines the amount of detail rendition as well as the contrast of the final photograph. Photo A was taken with only a fiber optic light of about 1/2-inch diameter, much smaller than the sculpture, which is about four inches tall. Even though the overall lighting is uneven, the area lit by the fiber optic has excellent detail and contrast. Increasing the size of the light source to six inches, just a bit larger than the subject resulted in photo B. Here the entire sculpture is well lit with excellent detail and contrast, except for the right side. Adding a small white reflector to fill in the shadow area results in photo C, producing the best overall reproduction of the subject. Increasing the size of the light source further results in photo D, which lacks the contrast and detail given by the smaller source. Notice also that the light is spilling onto the background paper so that it is no longer black. Adding a white fill card with this light source lowers the contrast and the detail even further, as seen in photo E.

"Strong side lighting can similarly be achieved with this system for dramatic effects."

camera lens and 45 degrees to the left or right of the lens (as shown on page 38). The 'fill' light is then located close to the lens but at a lesser output. Strong side lighting can similarly be achieved with this system for dramatic effects. While this would normally result in a contrasty photograph exceeding the latitude of the film, appropriate positioning and choice of lighting ratio will produce images limited only by the photographer's vision and technical ability.

If such a system is not available, there are many other possibilities for contrast control of lighting, including diffusers, reflectors (both additive and subtractive), as well as the "simple system" shown on page 24.

If no flash unit is available for contrast control, a diffusion screen between the light source and the subject provides an alternate solution. In the field, strong directional sunlight is a small source for larger close-up subjects, generating strong shadows and therefore high contrast. Combined with an inherently high contrast subject (a group of pale pink flowers with dark green leaves), sunlight can yield contrast ranges well outside of the film's latitude.

A diffuser (similar to the one shown on page 28), consisting of material stretched over a frame and placed between the sun and the subject, will lower the contrast in direct proportion to the degree of diffusion of the material. Thin sheets of artists' vellum will provide minimum diffusion, while heavy sheets of diffusion material like silks, fabrics and translucent plastics will give the effect of an overcast day.

The greater the degree of diffusion, however, the greater the light loss. This creates the necessity for an exposure increase, with either a longer shutter speed (which increases the likelihood of subject movement) or a wider aperture (with associated loss of depth of field).

A diffuser of sufficient size to be of practical use is not going to be very portable nor easy to handle in a breeze without help, so it may be impractical in many situations.

In the studio, the same types of diffusion material can be used to soften the light from direct flash or tungsten lamps. Mounting flash heads (either battery- or AC-powered) in light boxes also provides a soft, even, diffuse light source, but with a loss of light output. However, even the smallest commercially available light boxes provide a large source of illumination in relation to the close-up or macro subject, so care must be taken that contrast is not decreased too far. In combination with another smaller light source for modeling, light boxes are ideal as a fill light source to simulate an overcast sky.

As an alternative to a diffuser in direct sunlight, a reflector board or foldable reflector disc (like those shown on page 28) can be used on the side of the subject opposite to the sun to decrease contrast. White-surface reflectors will add soft fill light into the

shadows only. Silver-surface reflectors will affect the mid-tones as well as the shadows. Reflectors work best with large subjects and are only slightly easier to transport and use than diffusers.

When lighting contrast is low, the only contrast available is that which is inherent in the subject itself. At times, this is sufficient to yield a nearly full-range photograph, perhaps with only the brightest highlight values missing. This can be the case when taking pictures of small white flowers against dark green leaves with a large diffuse light source, either in shade in the field or with a large light source in the studio. The flowers provide highlight values, especially if covered with dew, the leaves provide mid-tones and a dark background provides shadow values and blacks. The result is a highly successful photo.

Where lighting and subject contrast is low, using a subtractive reflector such as black cloth on a board to absorb light on one side of the subject will slightly boost the contrast of the scene.

Exposure Determination

Once contrast and its relation to film latitude is understood, it is easy to determine the best exposure for a scene or to check the accuracy of the camera's automatic exposure reading. Automatic exposure readings are especially useful because they take into account any exposure increase required due to lens extension or accessory extension tubes.

Because internal camera meters measure reflected light, exposure adjustments may still be necessary if the subject's reflectance varies widely from 18 percent gray, for which all reflected light meters are corrected. In effect, dark subjects might well require less exposure than programmed by the automatic metering system, and light subjects more.

Automatic cameras can be fooled by lighting situations as well as by subject reflectance. When there is a strongly backlit subject or there is a predominance of specular highlights, in-camera meters will underexpose the midtones and shadows, overcompensating for the highlights by rendering them lower in the tonal scale than they are in actuality. In these cases, it is better to set the exposure manually rather than to rely on the camera's auto-exposure capabilities.

The simplest method of manually determining exposure in close-up and macro photography is to use an 18 percent gray card. This method relies on the in-camera meter and the fact that the meter is designed to deliver a correct exposure of a scene that can be averaged to 18 percent gray.

After composing the image precisely, place a small gray card in front of the subject and meter in manual mode. Then remove the card and shoot. This method is similar to using an incident light meter, but saves having to calculate the increased exposure required by lens extension. However, while that works well

"Automatic cameras can be fooled by lighting situations as well as by subject reflectance."

for exposure, it provides no indication whether or not the contrast range of the subject will fit within the latitude of the film. If the camera has a spot-metering mode, it can be used to obtain information about subject contrast.

By metering the highlights and shadows, it's possible to determine whether they will fall within the five-stop latitude of color transparency film. If so, the exposure can be set manually,

Table 2: Exposure Compensation

Magnification	Exposure Factor	Multiply Exposure Time By	Open the Lens By (f/stops)
0.1x	1.2	1.2	1/3
0.2x	1.4	1.4	1/3
0.3x	1.7	1.7	2/3
0.4x	2.0	2	1
0.5x	2.3	2.3	1-1/3
0.6x	2.6	2.6	1-1/3
0.7x	2.9	2.9	1-2/3
0.8x	3.2	3.2	1-2/3
0.9x	3.6	3.6	1-2/3
1.0x	4.0	4	2
1.2x	4.8	4.8	2-1/3
1.4x	5.8	5.8	2-1/3
1.6x	6.8	6.8	2-2/3
1.8x	7.8	7.8	2-2/3
2.0x	9.0	9	3
3.0x	16.0	16	4
4.0x	25.0	25	5
5.0x	36.0	36	5-1/3
6.0x	49.0	49	5-1/3
7.0x	56.0	56	5-2/3
8.0x	81.0	81	6
9.0x	100.0	100	6-2/3
10.0x	121.0	121	6-2/3

half-way between the maximum highlights and shadows. If not, the alternatives are to sacrifice either highlight or shadow information, or to take steps to lower the subject contrast.

An accessory hand-held meter, either incident or reflective, can also be used to provide exposure information. With either type of hand-held meter, compensation must be calculated, as shown in Table 2 (opposite page), whenever the magnification exceeds 0.1x (1:10).

Some manufacturers of hand-held meters offer macro-metering accessories, basically small incident light domes connected to the main meter by a fiber-optics cable. Hand-held spot meters, especially those metering one or two degrees, can also be used effectively to measure subject contrast as well as exposure, but the complexity of the calculation required makes them less than ideal.

A better alternative and one more conducive to the creative process is to meter as accurately as possible and then bracket around this exposure. Bracketing — adjusting the exposure in 1/3- or 1/2-stop increments around a basic value — is not an excuse for sloppy metering. Rather, it is a means of ensuring that the image, so painstakingly found and precisely composed, will be captured within the film's latitude and the photographer's vision.

There is a misconception that there exists a "correct" exposure for a subject. Only in the most mechanical of copy work is there a "correct" exposure. There will be times when the dramatic image resulting from underexposing one or more stops or the pastel tones of an overexposure is the "correct" rendition of the image on the film chosen.

Working with a Bellows

There comes a time when the magnification provided by close-up lenses, extension tubes and macro lenses, alone or in combination, still isn't sufficient to photograph what you want. That's when a bellows comes in. To understand how working with a bellows changes the rules, consider the diagrams on page 46.

As you can see, in general photography, the lens-to-subject distance is greater than the lens-to-film plane distance. When working with a bellows in close-up and macro photography, the opposite is true: the lens-to-film plane distance is greater than the lens-to-subject distance.

Since lenses are designed for the shorter of these distances to be at the rear of the lens, its possible to improve image quality by reversing lenses.

The diagram on page 46 provides some useful formulae that apply to most normal-to-medium-telephoto focal length lenses that might be used for close-up and macro photography.

"There is a misconception that there exists a 'correct' exposure for a subject."

General Photography vs. Bellows Photography

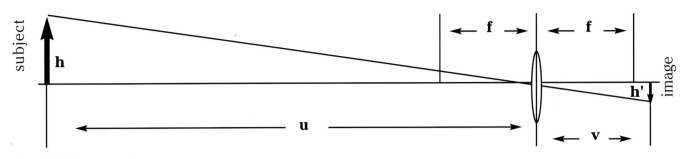

General Photography

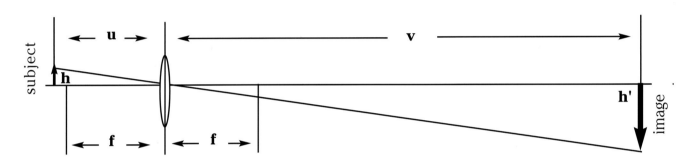

Bellows Photography

f = focal length
m = magnification
u = lens-to-subject distance
v = lens-to-film distance
h = height of subject
h' = height of image

Lens to image distance formula:
$$v = (m+1)f = mu = fu/(u-f)$$

Lens to subject distance (working distance) formula:
$$u = v/m = (1/m+1)f = fv/(v-f)$$

Magnification formula:
$$m = h'/h = v/u$$

Exposure factor = $(m+1)^2$

The first shows the relationship between bellows extension, magnification and focal length of the lens. It is:

$$v = (m+1)f$$

where 'v' is the bellows extension, 'm' is the magnification (image size/subject size) and 'f' is the focal length of the lens. It must be kept in mind that the bellows extension 'v' includes the thickness of the camera body (approximately 50mm), so it will be necessary to subtract this figure from the actual measured bellows extension.

To find the bellows extension required for a 3x macro photo with a 60mm lens, the equation becomes:

$$v = (3+1)60 = (4)60 = 240mm$$

Subtracting 50mm for the thickness of the camera body, we will need 190mm of bellows (or approximately 7.5 inches) to make a three-times life-size image with a 60mm lens.

Solving the same equation for 'f' — the focal length:

$$f = v/(m+1)$$

This allows the focal length 'f' to be calculated, if we can estimate the magnification. This can be done by using a millimeter ruler to measure the subject, since we know that the long dimension of a 35mm frame is 36mm. If the long dimension of the subject measures 12mm, then m=36mm/12mm or a magnification of 3x. If we pick a bellows extension of 150mm (and add in the 50mm of camera body depth) we have:

$$f = (150+50)/(3+1) = 200/4 = 50$$

So a 50mm lens would be correct lens to use in this situation.

Often it is important to know the working distance between the lens and the subject for a given set of conditions. With this

information, we will know if there will be sufficient space to set up lighting. Working distance, or lens-to-subject distance, is calculated from the formula:

$$u = v/m$$

In the situation immediately above, 'v' was (150+50)=200mm and 'm' was 3x, so the working distance would be:

$$u = 200/3 = 67mm$$

or a little more than 2.5 inches. This is the area available for lighting.

Exposure Determination With a Bellows

Most available bellows units provide some means of using the camera's built-in meter for automatic exposures. However, this is limited to continuous light sources or flash units designed to utilize the camera's through-the-lens automated flash system. These light sources are generally not the most appropriate sources for higher magnification close-up and macro photography in the studio. Therefore, it's important to understand how to use an external, hand-held meter to determine exposure.

Because bellows increase the distance light must travel after passing through the diaphragm of the lens, the exposure must be adjusted to compensate. The amount of compensation is expressed in terms of an exposure factor. The formula is:

$$\text{Exposure factor} = (m+1)^2$$

This means that either the aperture or exposure time must be adjusted by an amount equal to the magnification plus one, squared, in order to yield a correct exposure.

In the case of 3x magnification, the exposure factor is $(3+1)^2=(4)^2=16$ times the exposure indicated on an exposure meter. This means the shutter speed must be 16 times longer than that shown on an external light meter or the aperture must be opened up 4 stops.

For a magnification of 4x, the effective exposure is 25 times the metered shutter speed or an increase of 5 *f*-stops. Table 2

> ## "Therefore, it's important to understand how to...determine exposure."

gives the adjustments that must be made to the aperture or exposure time for various magnifications.

Once the magnification is known, a simpler way to determine the correct exposure is to set the external meter at the 'effective aperture' and read the compensated time or adjust the flash output based on the following formula:

$$\textbf{effective aperture = (m+1)(marked lens aperture)}$$

For example, if the lens will be used at $f/8$ and the magnification is 3x, the effective aperture is equal to $(3+1)(f8)$ or $f(4)(8) = f/32$. If the external meter is set at $f/32$, the correct exposure time for that magnification can be read directly from it, or the flash output can be adjusted until the meter reads $f/32$.

Pupillary Magnification

As mentioned above, these formulae are valid for most lenses normally used for close-up and macro photography. However, the formulae are strictly true only for lenses of symmetrical design (in other words, those lenses whose elements are mirror images on either side of the lens diaphragm).

Unfortunately, there are times that asymmetrical lenses, particularly retrofocus wide-angle lenses, are useful for higher magnifications with a bellows, and these formulae don't hold true for asymmetrical lenses.

It is easy to determine if a lens is of symmetrical or asymmetrical design. While holding the lens in front of an evenly-lit light source, with the lens stopped down enough that the diaphragm is visible, measure the diameter of the diaphragm while looking first through the front of the lens, then through the rear of the lens. If the two measurements are identical, then the lens is symmetrical.

Table 3: Pupillary Magnification

P	3.3	2.5	2	1.7	1.4	1.1	1	0.9	0.8	0.6
Lenses	200/4	20/3.5	28/2	35/2	50/1.4	50/1.8	55/2.8	105/2.5	85/2	135/2.8
	Micro	24/2	28/2.8	35/2.8		50/2	Micro			180/2.8
		24/2.8	35/1.4				55/3.5			135/2
							Micro			
							105/2.8			
							Micro			

If the measurement through the front is smaller than through the rear, the lens is a retrofocus design. If the opposite is the case, the lens is a telephoto design.

The ratio of the measurement through the front of the lens divided by the measurement through the rear of the lens is called the pupillary magnification, 'P'. For asymmetrical lenses, whenever the quantity (m+1) appears, it must be changed to (m+P)/P if the lens is used in its normal position, or (mP+1) if the lens is reversed. Table 3 gives the pupillary magnification for some Nikkor lenses.

If all the mathematics are a bother, running a set of tests with various lenses at magnifications that might be commonly used is a workable alternative. By keeping careful notes, the amount of exposure adjustment needed can easily be determined the next time that lens is used.

Until camera manufacturers redesign their bellows to allow electrical contact between the automated exposure systems in newer camera bodies and compatible lenses through the bellows system, coming up with accurate exposures will require certain calculations.

Film

Which film to select depends primarily on how the shot will eventually be used. For commercial printing in magazines, posters or calendars, or for potential sale as a stock image, then color transparency or black and white films are the best choice. Most professionals shoot exclusively with color transparency since the film can be scanned and converted to a black and white image.

If, however, the primary use is a color print for display, then color negative has traditionally been the film of choice, although new techniques for scanning color transparencies and printing them on conventional color photographic papers with digital printers yield results at least as good, though at somewhat greater expense. Black and white film is the best choice if the ultimate use is a black and white exhibition print.

Color transparency films, which possess less latitude than color negative films, offer the most choices in subject rendition, from the subtle and highly accurate pastel rendition of the 25 and 64 speed Kodachromes to the exaggerated saturation of Fuji Velvia.

Film choice should be governed more by the photographer's subjective interpretation than technical considerations of grain structure and sharpness, although photographers should be aware of the technical characteristics of films being used.

For the most part, the lower the ISO rating of the film, the finer the grain and the higher the sharpness. Kodachrome films have always been unequalled in fine grain and sharpness because of their unique formulation.

"Black and white film is the best choice if the ultimate use is a black and white exhibition print."

"...films with low ISO can present a problem when shooting in ambient light..."

Velvia, polar opposite to Kodachrome in saturation and color accuracy, also rates high in sharpness and low in terms of granularity. In close-up and macro photography, however, films with low ISO can present a problem when shooting in ambient light, if there is any amount of subject motion. Even if shooting at a modest aperture in hazy-bright conditions, shutter speeds can be in the range of 1/60 to 1/15, enough for the slightest breeze to cause subject blurring.

These films are an ideal choice when working with the two-flash system discussed above and shown in the top photo on page 25, and when shooting in the studio. Here, subject movement is eliminated by the electronic flash units, and the low ISO speed yields ideal working apertures of $f/8$ to $f/16$ depending on flash output.

While films in this ISO range have long been the mainstay of professional photographers who by necessity must consistently deliver the highest quality images, medium-speed (ISO 100-200) films are the best choice for close-up and macro photography in the field. Choosing between them is again a matter of personal preference, from the carefully formulated color accuracy of Kodak EPN, to the neutrality and excellent green reproduction of Fuji Provia, to the warmth of Kodak 100SW, to the high saturation and sharpness of Kodak 100VS, to the speed of Kodak ES200.

Color transparency films of high speed (ISO 400-1600) should not be summarily dismissed as totally inappropriate. Although as a class they are higher in contrast and grain and lower in sharpness than slower films, these very characteristics make them appropriate for creative, artistic expression if your vision tends to be in that direction.

Color negative films share the same general characteristics as color transparency films but they possess considerably more latitude (that is, tolerance to over- and underexposure). There is, however, far less difference between color negative films in each speed class than between color transparency emulsions. Color negatives require careful printing by a professional color lab to get the most from them.

Black and white close-up and macro photographs can be stunningly beautiful. Just look at the work done by photographers like Ansel Adams and Edward Weston. They most often worked with larger-format cameras and films, utilizing extensive filtration and some form of a zone system to map the subject's tonal scale to match that of the print material.

However, excellent results can be achieved by anyone with the time and interest to expose, process and print their own film, or who can find a lab capable of doing this satisfactorily. Black and white films in the range of ISO 50-100 are the best starting place for this process. Kodak T-Max 100 is currently unequalled in its ability to render subtle variations in value while maintaining high levels of sharpness and detail rendition.

One alternative in black and white photography for those photographers without darkrooms are the chromagenic films available from Ilford (XP2) and Kodak (400CN). These black and white films can be processed in color negative chemistry, then printed as black and white positives with excellent results. A final possibility for black and white photography which also does not require the photographer to have a darkroom is Agfa Scala, a film which, when processed by one of the few labs handling the film, yields a black and white positive image of exceptional quality.

Whichever film is finally selected, it should be appropriate to both the subject matter and the photographer's vision of the final image. The correct choice comes only with time spent experimenting with the alternatives available.

Filters

Filtering for close-up and macro photography serves the same functions as filtering for general photography. Any imbalance between the color temperature of the ambient light and the color temperature for which the film is balanced can be corrected, certain colors can be enhanced, contrast can be increased and, to a degree, artistic control over a scene can be enhanced

Daylight color films, both color negative and color transparency, are balanced for a color temperature of 5600° Kelvin, approximately the color temperature of sunlight from four hours after sunrise to four hours before sunset.

Table 4 shows the color temperature of common light sources, with higher Kelvin temperatures representing "cooler" (bluer) light and lower Kelvin temperatures "warmer" (redder) light. Where there is a large imbalance between the color temperature of the scene and the balance of the film, scene colors will not be accurate. With color negative films, significant color temperature imbalances can be corrected when printing. With color transparency films, corrections have to be made at the time of exposure with appropriate light-balancing filters.

Color temperature meters are available to precisely measure the color temperature of the ambient light. Light-balancing filters fall into two series: the 81-series of amber-tinted "warming" filters; and the 82-series of blue-tinted "cooling" filters.

Within each series, the filters are graded "A", "B", etc., with each letter indicating a progressively stronger correction in approximately 200° Kelvin increments. These can be combined for even stronger correction.

In practical use, however, there are only a few occasions where color correction is essential unless an objective scientific shot is required. In those cases, electronic flash should be used to override the ambient light and the exposure made on pre-tested and balanced daylight film.

Table 4: Color Temperature

Light Source	Color Temperature (in °K)
Candle flame	**1500**
Household bulbs	**2500-3000**
Quartz-halogen bulbs	**3200**
Sunset sun just above horizon	**3000-3200**
250w/500w photofloods	**3400**
Sunlight at 15° above horizon	**3800**
Sunlight at 30° above horizon	**4500**
Sunlight directly overhead	**4900-5800**
Electronic flash	**5000-6000**
Overcast sky	**6500-8000**
Clear blue sky	**10,000-20,000**

"It's a good idea to experiment to determine personal preferences."

In the field, color correction is primarily required in those situations when photos are made under overcast skies or in open shade. Here, the 81 series comes in handy, with the 81EF providing correction in all but the deepest shade. The 82 series of filters is seldom used, even when shooting early in the morning or late in the day, because the added warmth of the light often makes a pleasing photo.

The degree of warming provided by the 81-series is also dependent on the film emulsion used. Films that are inherently warm-balanced, like Velvia or the Kodak 'SW' series, will show a greater effect with the same filter than neutral-balanced films like Kodak EPP or the Kodachromes. It's a good idea to experiment to determine personal preferences. And like all filters, exposure compensation is required with both series. It is under one stop in most cases.

Where it is desirable to emphasize a particular color in the scene rather than to change the color temperature of the ambient light, another series of filters known as color-compensating (or CC) filters can be used. They are available in all six of the primary and secondary colors: red, green, blue, magenta, yellow and cyan. In each color, their strengths increase from a barely-colored .25 density to a full-strength 1.00 density.

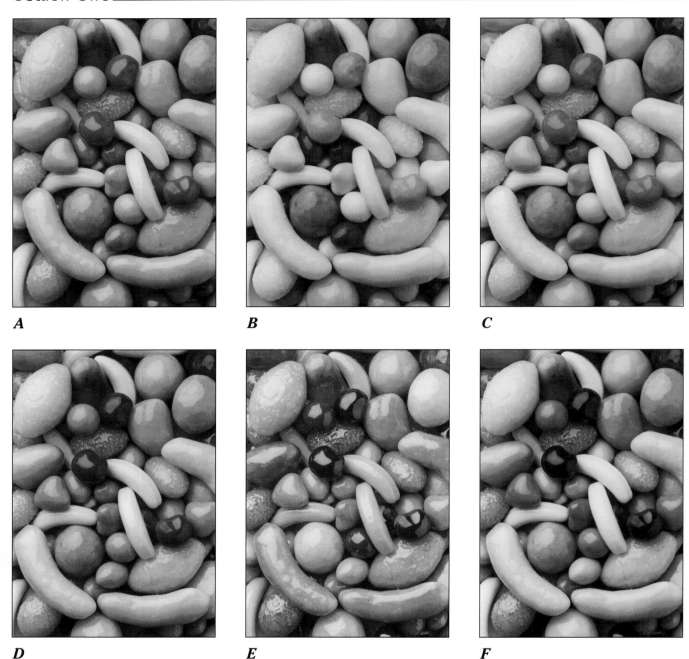

A

B

C

D

E

F

Above: Filters play an important role in black-and-white close-up and macro photography. They serve to separate gray values so that the resulting photo translates accurately or artistically from color to black and white. A color reproduction of this image can be seen in the color plates. In photo A, the subject is photographed with no filtration. Not necessarily bad, but it is somewhat lacking in contrast and lack of tonal separation between the yellow, orange and red items in the upper left. In photo B, a red #25 filter darkens blue and green items, but the yellow, orange and red are even closer in value. A deep yellow #15 filter used in photo C darkens blue and lightens green, yellow, orange and red (but not as much as the #25 red filter). In this case, the yellow, red and orange items in the upper left are still too close in value. Photo D uses a yellow-green #11 filter, which gives the best rendition of values for this subject. The yellows, oranges and reds are well-separated tones, while the greens are lightened and the blues darkened. In photo E, a #44 cyan filter totally changes the tonal relationships. Yellows, oranges and reds are darkened while blues and greens are lightened. Photo F uses a #58 green filter, which lightens green and yellow while darkening red, blue and magenta. In this scene, the filter renders a creative translation of tones. The #58 filter is especially valuable when a large amount of green foliage needs to be lightened.

Table 5: Filters for Black and White Photography

Filter	Filter Factor (Daylight or Flash)	Colors Lightened	Colors Darkened
11-Yellow/Green	4	Yellow, Green	Magenta, Blue, Violet
15-Deep Yellow	2.5	Red, Yellow, Orange, Green	Magenta, Blue, Violet
25-Red	8	Red, Magenta, Orange	Green, Cyan, Blue
33-Magenta	24	Magenta, Red, Orange, Blue	Green
44-Cyan	8	Green, Cyan, Blue	Red, Orange
58-Green	8	Yellow, Green, Cyan	Magenta, Red, Blue, Violet

Photographers who've had the occasion to shoot daylight-balanced color transparency film under fluorescent lights might be familiar with the CC30M filter, a .30-density magenta color-compensating filter commonly used to correct for the green component of the lights.

When color compensating filters are used, they effect all of the colors in the scene, and they have a particularly strong effect on neutral colors. That makes them most applicable when a single color dominates the scene; for instance when shooting a close-up of a palm frond where it's desirable to increase the saturation of the green. Here a strong CC30G could be used.

Similarly, a CC10R, CC20R, or even CC30R might be used to enhance the red saturation of rusted metal or a red rose, provided the background behind the rose is dark so that it doesn't show the effect of the filter.

A selection of CC filters in the green, red and yellow series don't take up much space or add much weight, but they can have a tremendous impact on close-up and macro photographs. Color-compensating filters require exposure compensation also, but again generally less than one stop even for the strong CC30 filters.

Another type of enhancing filter called a 'didymium filter' is also available. It has the effect of increasing the saturation of the warm colors and to a lesser extent the greens, while leaving the neutrals and blues relatively unaffected. It is particularly recommended for close-ups of fall foliage, but provides interesting effects whenever warm colors dominate.

For optimum results in black and white, close-up and macro photographers need to carry a full range of filters. When working in color, a bright red flower exhibits strong contrast against a dark green background (which is explained in greater detail in the next chapter's discussion of visual contrasts in black and

"Color-compensating filters require exposure compensation also..."

white) and without filtration, the image would be dark gray on dark gray. Strong red filtration is called for to lighten the red flower and darken the green foliage. With each color that is lightened, its complement is correspondingly darkened. Filtration is effective in increasing the contrast of a yellow sunflower against a blue sky, but ineffective when photographing a yellow bee against a yellow flower. Table 5 presents the most useful filters for black and white close-up and macro photography, including the colors that are lightened and darkened and the exposure compensation required, which can be considerable.

Filters are useful not only for correcting or enhancing colors, but also for providing a degree of artistic control over the subject. Soft-focus filters are one type that can produce particularly appealing effects if used with an appropriate subject. The degree and even the type of soft focus produced varies from manufacturer to manufacturer. Some combine softening with contrast reduction, while others render soft halos around sharply-detailed areas. They may not be for everyone, but they're fun to experiment with.

"Polarizing filters can also be used in close-up and macro photography."

Polarizing filters can also be used in close-up and macro photography. They are useful in increasing the saturation of colors, particularly in eliminating the reflection of sunlight off shiny green leaves, darkening the sky when photographing against it, or eliminating the reflection off the surface of water when shooting in tide pools. Working with polarizing filters, however, takes practice. It's important to get just the right angle to eliminate reflections. Exposure compensation of a stop or more is required. Furthermore, it is important to use the correct type of polarizer for the camera being used. Some models require a linear polarizer, while others call for a circular polarizer so that the automatic features to function properly.

Once the basics of camera operation, lighting and composition have been mastered, filters provide a means of perfecting images. They are one way of developing a unique style and vision. In the next sections we'll look at ways to apply this basic knowledge to field and studio close-up and macro photography.

Chapter Three
Field Photography

Certainly, one of the most popular forms of close-up and macro photography is capturing images of the natural world. Whether the subjects are insects, reptiles, aquatic life, flowers, natural geologic formations or man-made constructions, the endless variety provides a lifetime's worth of photographic opportunities.

Capturing these images in a way that satisfies the vision of the photographer can range from a simple project to a daunting task. Minimal equipment can often provide satisfactory results. However, for the best shots, specialized camera and lighting equipment is required. This section of the book will address the areas of camera, lens, and lighting selection for field photography and how these selections apply to close-up and macro photography in the field.

Equipment, lighting and compositional considerations are, to varying degrees, within the control of the photographer. What makes close-up and macro field photography most challenging are those elements that are beyond the photographer's control, such as living and moving subjects, wind and weather, and ambient lighting. Dealing with these elements can try the patience of even the most dedicated photographer. But it ultimately separates the devoted from the occasional practitioner.

"...the endless variety provides a lifetime's worth of photographic opportunities. "

Cameras

The pleasure of recording natural images on film is surpassed only by the pleasure of discovering them in remote and unexpected places. Often this means extended hikes away from easily accessible locations. With this in mind, equipment selection must weigh portability equally against with the equipment's ability to render quality images under a variety of lighting conditions.

Since high-magnification macro images are extremely difficult to shoot in the field because of potential subject movement, most images will be captured in the close-up or near-macro range up to 2x magnification. At this scale, the need to lock up the mirror is unnecessary, as is the need to interchange viewing screens and viewfinders if a right-angle viewer is available for attaching to the viewfinder eyepiece.

With focus so critical to the success of the photograph, the camera should be set on manual focus instead of autofocus. Focus decisions are too important to be left to automation. Even the

Above: Some subjects, such as this Protea bloom, can yield a number of different but equally interesting images. This one, shot in open shade, uses color and sharpness contrast to draw attention to one aspect of the flower.

Opposite page: This image was taken at a local orchid show using the "simple system" as described on page 23.

Below: With only a few drops of water, this plumeria bloom comes alive.

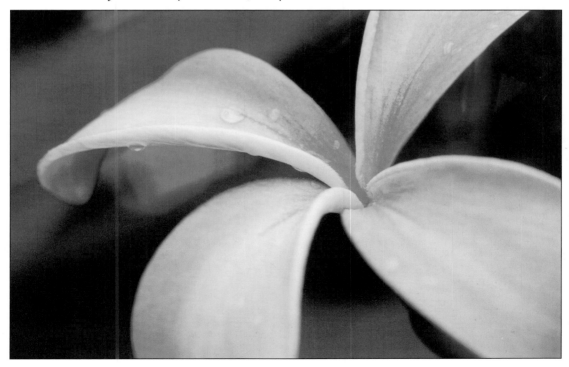

external cable release can be eliminated at lower magnifications if the camera release is electronic rather than mechanical.

In the field, an accurate in-camera light metering system saves the weight and space of carrying an external meter while automatically making the adjustments that higher magnification exposures require. Automated exposure settings, both for ambient light and flash lighting situations, are highly desirable. They should support both shutter speed and aperture priority, as well as provide for manual control.

Also important is the ability to move the flash off-camera and attach it through a remote flash cord, while retaining through-the-lens flash automation. And for tripod mounting, a tripod socket centered under the lens is essential.

As a minimum then, the 35mm single lens reflex camera body for close-up and macro photography field work then should have the following essential features: exposure automation for ambient light and flash; the ability to move the flash unit off-camera while retaining flash automation, and a tripod socket.

For years, I have used the Nikon F3 for close-up and macro work. It possessed all of the features essential for close-up and

Below: Many photographic subjects in the field lie close to ground level. When choosing a tripod, it's important that it can be adjusted to ground level or that accessories like the right-angle bracket and extension arm made by Gitzo for their tripods are available.

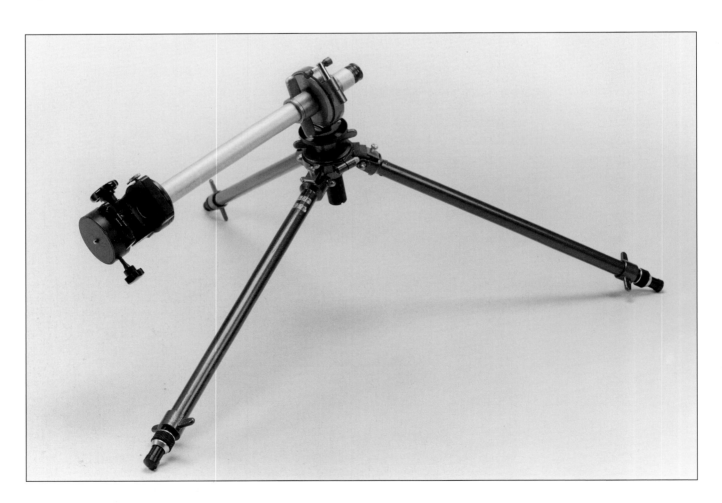

Left: The dynamic of diagonal lines is emphasized by the use of color contrast in this study of tropical leaves.

Below: Natural light is rarely the best for photographing close-up and macro subjects. In this case, the day was heavily overcast and the orchid would have photographed very two-dimensionally. Using the "simple system," with the flash off-camera and to the left providing all of the lighting, created light and shadow areas to provide dimension. It was also possible to make the shot without a tripod at a small lens aperture for maximum depth of field, since the flash duration is short and the light output is high at close distances.

Above and below: The eye is first drawn to the brightest area of a photograph, so it is important that it be sharply in focus. The wrong choice in the photo above would have been to focus on the far petals of the tulip even though they form a strong visual contrast with the dark background. In the bottom photo, focusing on the flower isolated against the dark background is the right decision.

Right: For field work, a light weight but rigid ball head mounted on a strong but light-weight tripod provides a solid platform. A short center column and legs that adjust independently to a nearly horizontal position make low-angle photos possible with this Gitzo model.

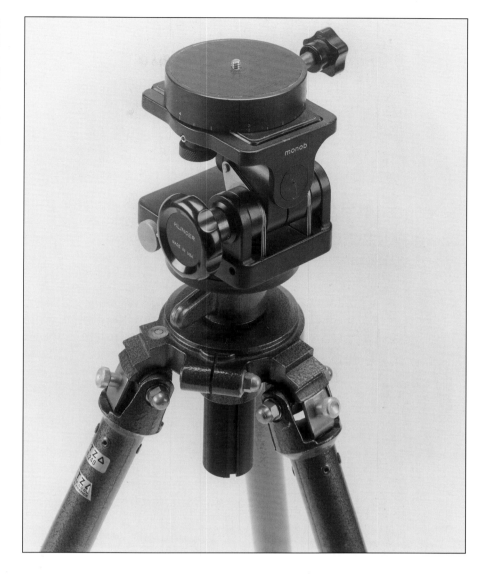

macro photography, both in the field and in the studio, as well as having a vast array of close-up and macro photography accessories available. Recently, I have switched to the N90s and now to the Nikon F100 because of their lighter weight and advanced flash automation for fill-flash.

Lenses

A manual-focus macro lens of 90-105mm is the best choice for field work. Although slightly heavier and bulkier than shorter focal length macros, the increased lens-to-subject distance afforded by the longer focal length simplifies the photography of live subjects.

This lens, along with a set of supplementary close-up lenses and some auxiliary lighting, comprises the minimum equipment set for the close-up and macro photographer in the field.

"A manual-focus macro lens of 90-105mm is the best choice for field work."

Other Equipment

While there are certainly many times when I leave it home (and many other times when I wish I had left it home), a medium-weight tripod with a ball head and quick-release platform should be part of the close-up and macro field photographer's standard gear. For a little more magnification with very little added bulk, one or more extension tubes should also be carried.

Lighting Considerations

"...ambient light will be sufficient for field work..."

In many cases, ambient natural light will be sufficient for field work, particularly during the early stages of interest. In time, however, some form of supplemental lighting will be desired, from simple fill cards to bounce light into shadow areas to auxiliary flash units for fill or main lighting. The economy and simplicity of diffusion screens, fill cards, and bounce reflectors, whether white, silver or gold, is offset by their bulk in transporting them and by the need to position them properly for the desired effect.

For those fortunate enough to have an assistant, friend or spouse available, these light modifiers can be the ideal solution, since their effect can be seen and adjusted while composing through the viewfinder. For those working alone, they all require either their own support, or the photographer to operate the camera one-handed while positioning them where necessary with the other.

Auxiliary battery-operated flash units, moved off-camera but connected by an extension cord to provide full through-the-lens flash automation, are the nearly ideal lighting accessory. Depending on the ambient lighting conditions and the photographer's creative desire, what I have called the "simple system" shown on page 24 can provide soft fill or directional main light for the subject.

Beyond the simple system is the more complex arrangement shown in the top photo on page 25. This provides full control over main and fill lighting while still utilizing the full range of flash exposure control. This system essentially frees the photographer from concerns about ambient conditions, from light level and color temperature to subject movement, since the short flash duration will freeze nearly any motion from live subjects or from the wind.

Lighting contrast is one of the many concerns for the field photographer. There is usually too much of it, like direct sunlight around mid-day, or too little of it, like a shady forest floor. Both of these situations can be saved with the "simple system."

In direct sunlight, the combination of automatic camera and off-camera fill-flash can easily be used to reduce contrast. Use the ambient light exposure without the flash as the base exposure. This is usually accomplished by setting the camera on Automatic, Shutter Speed Priority or Aperture Priority.

This torch ginger flower was deep in the shade in the rainforest with little contrast in its surroundings. Here the flash in the "simple system" was held above the flower and functions as a main light, set one stop brighter than the background.

Backlighting from behind and to the left isolates this bird of paradise from its background. In this instance, no fill is needed since the most interesting parts of the flower are already well lit.

Green insects on green foliage provide little color contrast and ambient light may not be high enough to allow sufficient depth of field to get the entire body in focus. Using a flash as the main light allows the subject to be isolated from the surroundings and a smaller aperture to be used while handholding the camera. The flash was positioned below the worm for an unearthly, horror-lighting effect.

Above: Abstract designs are everywhere. Here sunlight casts the shadow of a wire screen on weathered, painted wood. Man-made as well as natural subjects provide an endless source of images for the close-up and macro photographer.

Below: Weathered paint on an old metal sign becomes a study in texture. Bright mid-day sun, which would normally be avoided, provides the necessary contrast and color saturation.

Above: Soft overhead lighting from an overcast sky outlined these yellow ginger flowers from their forest surrounding. The strong diagonals give a sense of motion to the static subject.

Below: To take this photo of plumeria, the fill flash was set one stop below ambient light exposure to reduce contrast and fill shadows.

Above: Many striking macro photographs consist of repeating abstract patterns, sharply focused and highly detailed, as a section of this daisy would have been if shot straight on. But instead, the decision was made to shoot from an angle with limited depth of field to suggest the dynamic of the flower's opening.

Below: Film choice should be appropriate to the subject. Here Kodachrome 25 accurately portrays the soft pastels of the bougainvillaea.

"Experiment here with different exposure compensation on the flash..."

Using this exposure for the camera, adjust the exposure compensation of the flash to -1 stop for a 1:3 highlight-to-shadow ratio or -1 2/3 stop for a subtler fill (my usual choice). Position the flash close to the lens and shoot. Experiment here with different exposure compensation on the flash as well as diffusion over the flash head and varying flash positions.

Moving from sunlight into shade or shooting under an overcast sky eliminates any contrast problems, since the light source is now enormously larger than the subject. This lighting presents its own set of problems, though. Light loss due to the lower light level and the frequent need to filter the film to decrease the amount of blue in these situations must be dealt with. Flat lighting generally results in a lack of contrast.

Where subject contrast is low, using a subtractive reflector such as black cloth on a board to absorb light on one side of the subject will add a slight boost to the contrast of the scene. More effective in these situations is, again, the "simple system."

Metering the ambient light without the flash yields a base exposure for the low-contrast scene. Set the lens to underexpose by 1/2 stop if using manual mode, or adjust the exposure compensation on the camera to -1/2 or -2/3 stop if using an automatic mode. Then set the flash to overexpose by 1 stop, position it as described earlier (45 degrees above and 45 degrees to the side) and shoot. This makes the flash the "main" light and the ambient light the "fill" and yields results similar to diffused sunlight. Experiment with different ratios for different subject contrasts, diffuse the flash for subtler effects and reposition the flash to simulate different sun positions.

This automatic camera and off-camera flash technique is particularly easy and effective when working alone. With the flash providing fill light, this technique can be utilized without a tripod in brightly lit situations, such as photographing close-ups of flowers in public gardens or other areas where tripods are not permitted. It is so easy to master that it provides a reliable framework for experimentation with lighting ratios, diffusion, colored gels over the flash, and more.

Chapter Four
Studio Photography

In the studio, a photographer shooting close-up or macro work has virtually complete control over both the subject and the environment. Unlike field photographers, who have to compromise creativity; worry about the portability of equipment; deal with ambient lighting and weather conditions; and worry about subject movement, studio photographers can concentrate on the creative side of shooting.

There's even an expanded range of subject matter, encompassing not only those elements of the outside world that can be moved into the studio, but also the full range of small-scale man-made objects, from jewelry to stamps.

In the studio, the challenge is to create rather than discover photographs. Studio close-up work makes it possible to use as much equipment as is required to come up with the best image. It presents a real opportunity to "build" the right photograph, regardless of how complex the set up might be and how intricate the lighting requirements are.

On the other hand, studio work presents its own set of challenges, requirements and difficulties. Most notably, there is no excuse for many of the problems that might come up on locations. Distracting backgrounds, unbalanced lighting, poor composition and various image problems can't be explained away as environmental factors. All these things are within the control of the photographer. The main difference between field and studio work is the ability to utilize more complex camera and lighting equipment.

Something has to be understood before getting into detail. When talking about studio work, it doesn't mean it has to be done in a full-fledged commercial studio. Almost any space with an available area of at least 4'x4'x4', where the ambient lighting can be controlled, works for close-up and macro photography. It isn't the size of the space, but its creative use that determines success.

Cameras

There are many factors that determine the ultimate quality of an image. In commercial applications, the overriding consideration is to maximize image detail. It's always better to capture the maximum amount of image detail at the time a photo is being taken rather than trying to gain it through enlargement when the

> "In the studio, the challenge is to create rather than discover photographs."

Below: For high-magnification photography in the studio, a macro lens mounted on a bellows will produce the highest quality results. Since the Nikon bellows does not connect the lens and the camera mechanically or electrically, a double cable release is required to first stop down the lens to its working aperture and then to release the shutter. Locking the mirror up prior to exposure eliminates any possibility of vibration.

image is printed. The more image information that's in the original, the higher the quality of the final print.

This is why most commercial photographers who specialize in close-up and macro photography in the studio use large-format (either 4x5 or 8x10) equipment. Additionally, the studio environment encourages a more patient, studied approach where ultimate image quality is the overriding consideration. However, for purposes here, the emphasis is on 35mm equipment, which, for all but the most demanding applications, is quite suitable.

There are various things to look for when selecting a 35mm single lens reflex camera. The system should have an available bellows unit, a tripod socket, mirror lockup, the ability to connect an external cable release, a PC-outlet for external flash, and interchangeable viewing screens and viewfinders.

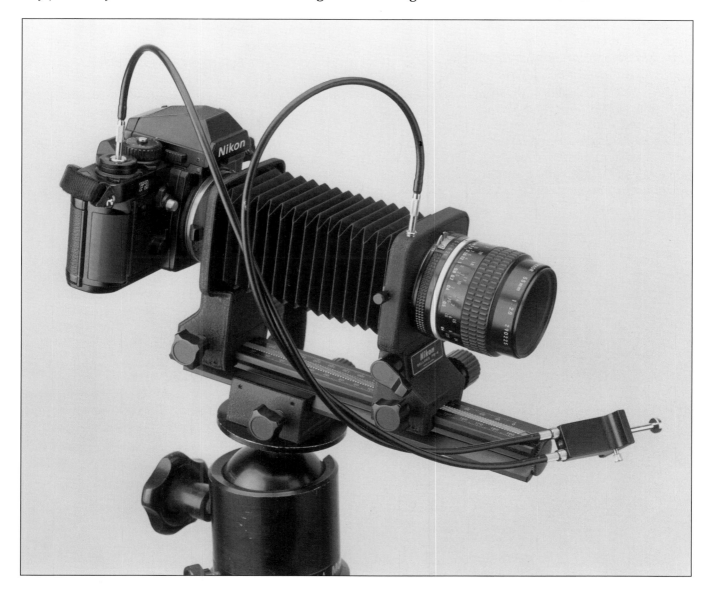

Less essential features include automated exposure and flash control, since they are usable only for lower-magnification photography. The photo below shows the typical studio camera setup.

Again, my personal choice had been the Nikon F3, which provided all of the essential features for both studio and field use. More recently I've added the Nikon F5. But most major camera manufacturers have equivalent systems designed for close-up and macro photography.

Right: A tripod for the studio should be as massive and stable as possible, since it may be used at high magnifications where the slightest vibration can spoil a photo. A crank-up center column simplifies making small vertical adjustments on this Bogen model. A platform head with adjusting arms, rather than a ball head, allows small adjustments to be made in one plane without effecting other planes. A quick-release plate comes standard on this head.

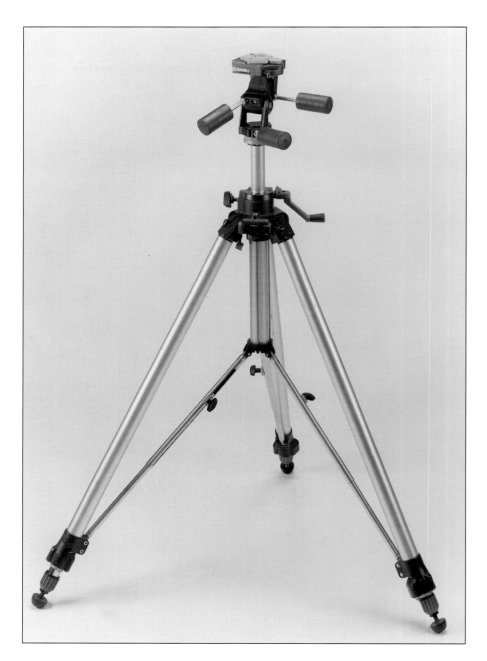

Right: In the studio, a platform head and a crank-up center column allow camera adjustments to be made in one direction at a time. With the addition of a focusing rack or a double-track bellows for adjustment of lens-to-subject distance, independent control in all directions and angles is possible.

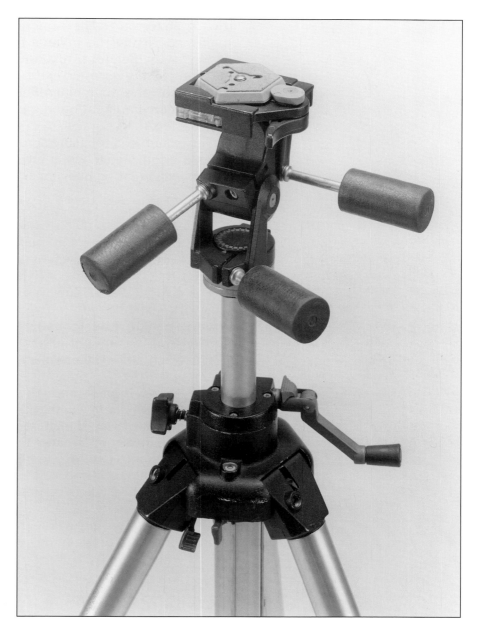

"While mirror locking is important, automation isn't."

At lower magnifications, studio work is similar to field work. However, there are differences at higher magnifications.

For example, at higher magnifications, the ability to lock up the mirror is essential even with cameras that have the most effective mirror dampening mechanism in order to prevent vibration from degrading the image. While mirror locking is important, automation isn't. Automated features are not generally available when bellows are attached and the mirror is locked up anyway.

Through-the-lens metering in stop-down mode is a useful feature when working with bellows and continuous light sources. Stop-down metering allows the exposure to be determined and

then transferred to the camera body and lens. The exposure is then made using the manual mode. Similarly, when working at higher magnifications, it's important to be able to attach a mechanical or electronic external cable release, to prevent vibration. Also, the high-magnification viewfinders and specialty viewing screens mentioned earlier can make focusing considerably easier.

For example, a focusing screen such as the Nikon Type M provides a bright image while incorporating millimeter markings to assist in calculating image magnification.

Lenses

In the studio, there's no need to compromise since there's no need to worry about weight and portability. Use the optimum lens for the situation.

For close-up work (up to a 1:1 magnification), a true macro lens with a focal length between 50 and 200mm works very well. Which specific lens to use depends on the working distance needed and the amount of background desired in the photo.

For example, a 100mm macro lens will provide approximately six inches of working distance at 1:1 while a 50mm will provide about three inches and the 200mm about twelve inches. Similarly, the 100mm will take in 1/2 the amount of background as the 50mm, but twice the amount as the 200mm.

At magnifications greater than 1:1, practically any lens from 20mm to 200mm can be used in conjunction with the bellows. A 55mm $f2.8$ Nikkor Micro lens provides continuous magnification from 1.1x to 3.8x when mounted in the normal position on the Nikon bellows.

When mounted in reverse, it provides slightly less magnification (3.5x) but improved image quality and nearly three times the working distance.

Reversing Rings

"Lens reversing rings are an essential accessory when working with magnifications greater than 1:1."

Lens reversing rings are an essential accessory when working with magnifications greater than 1:1. That's because camera lenses are designed with aberrations corrected when the distance from the lens to the subject is greater than the distance from the rear of the lens to the film. In general photography, this is always true.

In macro photography, it is true only for the longest (200mm or greater focal length lenses.

With all other focal lengths, image quality will improve if the lens is mounted in reverse for macro reproduction ratios greater than 1:1.

Mounting a lens with reversing rings usually results in the loss of all of a camera's automated control functions. Some, however, do allow auto-diaphragm control on certain camera models.

Bellows

Where close-up and macro photography in the studio differs most from field work is in its ability to render higher quality images at higher magnifications. That's primarily due to the ability to use a bellows, which is impractical to deal with in a field situation because of their fragile nature. In studio work, bellows are the equipment of choice for higher magnifications.

While it is certainly possible to compose and expose a photo by trial and error using a bellows, that's not the best approach. Attaching a lens, guessing at a bellows extension, finding, framing, focusing and composing the subject only to find that there is not enough bellows extension available and having to repeat the entire process with a shorter focal-length lens can be frustrating.

Learning to work effectively with a bellows, as discussed in Section 2, is one of the first objectives for doing studio work. Once working with bellows has been mastered, a whole new world of close-up and macro photography opens up.

Lighting Considerations

The same lighting principles that apply to close-up and macro photography in the field apply in the studio. The difference is that all of the lights, the lighting setup, and the ratio between the different lights must be supplied by the photographer.

To achieve optimum results and come up with the best detail and contrast, select a light source that is approximately the same size as the subject. For some studio subjects, the same flash units can used in the studio that are used in the field.

However, since portability is not a concern and AC power is available, the ideal light source is an AC-powered flash unit with a minimum of three separate flash heads. One head can be used as the main light, one for fill and one to provide background illumination. Additional heads can be used on the subject as effect lights, or to provide multiple effects in the background. The short duration of the electronic flash eliminates any possible vibration problem while providing a consistent color temperature. And, unlike continuous light sources, electronic flash keeps the studio relatively cool. But the real advantage of AC units is their built-in modeling lights. They make it possible for a photographer to preview the flash effect while providing illumination for focusing.

When photographing natural subjects in the studio, the idea is generally to come up with a natural-looking image. The lighting should simulate natural outdoor lighting as closely as possible. This can be done by mounting one lighting head in a softbox positioned above the subject, or suspending diffusion material stretched on a frame over the subject and directing one light through it.

This becomes, in effect, the 'sky' — a broad, nearly shadowless source. The larger the overhead light source, the softer the shad-

ows will be, and the lower the overall contrast. For some subjects, this light may be sufficient, simulating the type of lighting you would find in bright open shade, but without the strong blue component. However, for most subjects, the overhead light should be thought of as fill light. A main light is required to provide modeling and depth to the subject, and reflector cards should be used as needed to fill in any problem shadow areas created by the main light.

The main light is generally positioned 45 degrees above the lens and 45 degrees from the plane of the subject on the camera side. In effect, this simulates late afternoon sunlight, but again without the color temperature problem.

Reflectors of various sizes or various reflectivities, from the harsh fill of a mirror to the soft fill of a large white card to the warmth of a gold card, are then positioned to fill in shadow areas created by the main light.

As a general rule, the size of the main light should approximate the size of the area being photographed. When the source is much larger, the rendition of detail and, to a lesser extent the contrast, suffer. This is one reason why fiber-optic cables of approximately 1/2 inch or smaller are employed in studio close-up and macro photography. The other reason is their small physical size, which allows them to be positioned in the tight lens-to-subject spaces inherent in close-up work.

Lighting with fiber optics follows the same rules that apply to larger light sources. However, the small diameter of their light output requires more careful positioning, just as using a spotlight in general photography requires more care than a large diffuse source.

Diffusers are supplied with or can be made for fiber optics to soften the light, and there are even spotlights and snoots available.

Something that is frequently overlooked, or at least not given the attention that it deserves, is the background in close-up and macro shots.

What to use for a background is very important. The easiest solution, and an acceptable one for many subjects, is to simply let it go black, mimicking the field photographer's carefully positioned black cloth behind the subject. The exposure reading of the black background should be at least two stops below the reading for the subject to ensure a rich black.

When black doesn't work, there are other options. If the goal is an outdoor look (for instance, to simulate a garden), a photographic print of a scene can be positioned behind a flower being shot in the studio. Even though the background will be out of focus, it's important to match the subject lighting to the background lighting to make the illusion believable.

On the other end of the spectrum, when a completely white background is required, there are several options. One is to

place the subject on a sheet of heavy diffusion material and evenly backlight the material. Then main and fill lights are positioned to light the subject. These lights, however, may cause shadows on the background.

An alternative which provides shadowless lighting is to suspend the subject above the diffusion material, if possible, or to place the subject on a sheet of glass above an evenly-lit white background. Multi-coated glass available at frame stores is ideal. It's coating greatly reduces any reflections from the subject. In all cases the background exposure should be no more that two stops greater than the subject exposure to guard against flare from the background reducing the contrast of the image.

When white or black backgrounds won't work, seamless background papers in a variety of colors are available from commercial camera supply stores. But select the color and texture carefully. Properly chosen, seamless can provide interesting color and texture to the subject.

A light source aimed at the lower part of the background and falling off in value to the top will provide gradation, like the evening sky after sunset. A spotlight aimed at the background behind the subject will provide a bright area to draw the eye to the center of the photo.

This is particularly effective if the background color contrasts well with the subject's color. Colored gels can be added to the background light to create a large variety of effects. Shadows and patterns can be easily created on the background by introducing objects or cut-out patterns between the light source and the background.

When a sufficient number of flash heads are available, richly saturated color backgrounds can be created by shining lights covered with colored gels through a sheet of diffusion material placed behind the subject. One broad light can create the effect of a colored seamless background, but with more saturation. Additional lights with grid spots to control their light spread and colored gels can create all sorts of interesting effects.

The diffusion material can be of many types, from thin artists' vellum to heavy sheets of 3/8-inch white plastic. While each provides a different effect, I prefer the strong diffusion provided by white plastic (Plexiglas).

If lighting from the subject spills onto the diffuser because there is not enough room available between it and the subject, the photograph needs to be done as a double exposure — one for the foreground and one for the background.

During the foreground exposure for the subject, the diffuser must be covered with black light-absorbing material. When this exposure is complete, the shutter must be carefully recocked without advancing the film.

For the background exposure, the black material covering the diffuser is removed and the background exposure is made on the

"It's coating greatly reduces any reflections from the subject."

same frame of film. Using these techniques however, will make the image look very much like it has been created in the studio. See the Appendix (page 90) for a sample photo session in the studio featuring crystals.

With this background, let's look at some applications for close-up and macro photography in the studio.

Chapter Five
Subject Considerations

Close-up and macro photography in the studio falls into two general categories: photography of two-dimensional subjects, such as making copies or slide duplicates; and photography of three-dimensional subjects, similar to what would be done in field photography but making use of all of the controls that a studio offers. Lets look briefly at two-dimensional applications before addressing some ways to photograph specific three-dimensional subjects.

Two-dimensional Subjects

One specialty that regularly requires close-up and macro capabilities is the photography of flat subjects, which can include everything from making a slide from a color print to photographing paintings, coins or stamps.

While the primary consideration in most of this work is to create as accurate a reproduction of the original as possible, there are opportunities for creative interpretation using multiple exposure, filters and interpretive lighting.

For this type of work, a normal focal length (50-60mm), true macro lens (one which provides flat-field correction for corner-to-corner sharpness) is essential for optimum results. Photography of two-dimensional subjects is best handled using a copy stand, where the camera is mounted on a rigid column allowing the film plane to be positioned exactly parallel to the plane of the subject (as shown on page 78). Tripods, even when equipped with extension arms to offset the camera from the legs, are difficult to use for these setups.

Many copy stands come equipped with lights, usually "hot lights" instead of electronic flash, mounted at a 45 degree angle to the base with sufficient coverage to evenly illuminate the entire area of the base. This type of lighting is designed for accurate reproduction, not creative interpretation, and type B-balanced film delivers just that.

The procedure for doing copy work is straightforward. The camera is aligned with the film plane parallel to the subject, using a bubble level if necessary to guarantee precise alignment. Camera height and focus is adjusted so that the desired area is framed properly in the viewfinder.

With the lights on, an 18-percent gray card is placed in the subject position and the exposure measured through the lens

"Photography of two-dimensional subjects is best handled using a copy stand..."

Right: A copy stand is the best way to make photos of flat, two-dimensional subjects at any magnification. A rigid column supports the camera and lens on a sliding platform directly above the subject. Lights are placed at the sides at a 45-degree angle to the subject to provide even illumination.

assuming a lens aperture of $f/8$. The camera should then be set on manual at an aperture of $f/8$ at the metered shutter speed and left this way as the copies are made. The exposure needs to be changed only when the magnification is changed. Automatic exposure shouldn't be utilized. Using automatic exposure will result in different exposures for different subjects' reflectivities. Hence, dark subjects will be rendered too light and light subjects too dark.

With a particularly shiny subject, such a glossy photograph, it may be impossible to eliminate the reflection of the lights or even the camera in the subject. In such cases, polarizing filters need to be placed over the lights and the camera lens to eliminate the reflection. Sheets of polarizing material are available from a number of suppliers, and the axis of polarization is clearly marked. When mounting these filters in front of hot lights, sufficient room must be allowed for air circulation to prevent the filter from melting.

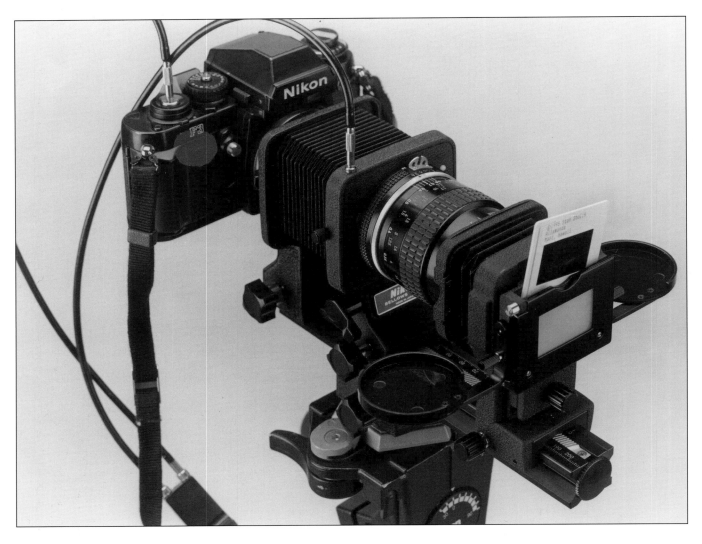

Above: Slide duplicating at 1:1 or greater is possible with the addition of a slide copying adapter, like the Nikon PS-6 shown, to the camera, bellows, macro lens combination used for photographing three-dimensional objects in the studio.

Page 79: Photographing small two-dimensional subjects like this stamp is easily done with the camera mounted on a copy stand. However, if the need is only occasional, using a ring-light (as was done here) is a quicker option.

With one light turned off, a polarizing sheet is placed over the other light (which is on) and the polarizing filter on the camera lens adjusted to eliminate any reflection. The other light is then turned on and its polarizing filter rotated so that it does not add a reflection.

Metering is best accomplished by using a separate hand-held incident light meter with a flat diffuser (rather than the customary dome generally used for three-dimensional subjects) to meter the light passing through the polarizing filters over the lights. This reading needs to be adjusted for the image magnification (as detailed in Table 2 on page 44) and additionally to compensate for the polarizing filter over the lens which can absorb as much as two stops of light at its maximum polarization. Bracketing or shooting test film, if possible, is definitely called for here.

The copy stand can also be used for slide duplication as long as a diffuse, color-corrected source is available for backlighting

These small candies become a study in color and shape. They also form the basis for a study of the effects of various black-and-white filters when photographing in black and white (as described on page 54).

Above: Photographing crystalline structures requires a good deal of experimentation with lighting, so it is best done in the studio. The steps in producing this photograph of apophylite with stilbite are described in the Appendix.

Below: Combining crystals and shiny reflective surfaces calls for a relatively large light source in order to reveal the faceting while avoiding burnt out highlights. The photo on the left was taken with the main light alone, while the photo on the right shows the effect of adding a white reflecting card to the right.

Above: Even everyday vegetables like this radicchio reveal interesting patterns when photographed close-up.

Below: The leafy structure of this ornamental kale plant was photographed with a 200mm macro lens.

Shiny metal objects are best photographed with tent lighting, which gives broad highlights. The inside of this old chronometer combined shiny with brushed metallic surfaces, which photograph well using either tent lighting (above) or a ringlight (below). The tent lighting can be arranged to form directional lighting, while a ringlight provides illumination from all around the subject.

the original transparencies. Such a source can be easily fashioned by placing the light source behind a small (4 inch by 6 inch) piece of 1/4-inch white Plexiglas and masked so that only the necessary area for the slide allows light to pass.

Although "hot lights" can be used for slide duplication and provide the advantage of through-the-lens metering, the heat they generate can be a problem. With electronic flash, complete exposure automation at 1:1 or less can be achieved with the appropriate combination of camera, lens, and flash unit with automatic extension cord providing automated through-the-lens exposure.

For slide duplicating at 1:1 and greater magnifications, bellows units with an accessory slide-copying adapter are available from a number of manufacturers (see photo on page 80). Some provide through-the-lens metering and flash exposure control.

If slide duplicates are frequently required, self-contained slide duplicators are available. They provide the greatest degree of control over slide reproduction, combining a color enlarging head for color-correcting originals or creative effects with an electronic flash for exposure. But they can get expensive.

Any of the above systems which provide the ability to backlight subjects can also be used for creative effects. Combining translucent materials with colored gels and mounting the combinations in glass slide mounts will provide an infinite variety of possibilities for backgrounds, title slides, multiple exposures, etc.

Mounting a bellows between the lens and camera makes it possible for macro photographs of stamps and coins to show the fine detail inherent in those subjects. When photographing coins, more creative lighting is required than that provided by a copy stand because of the highly reflective nature of the subject. Bright, shiny coins act as tiny mirrors, reflecting the environment around them. The simple way to photograph them is to use a relatively long focal length lens (100mm or more), placing the coin on (or slightly above on a small hidden support) a dark background.

The coin is placed slightly off-axis to the lens so that the lens and camera are not reflected in the surface. By using a long focal length lens, there is less feeling that the coin is being photographed from an angle and less chance that the coin will not be rendered completely round. The longer lens also provides a greater working distance. Then a heavy white diffusion material is angled from the camera lens to the surface supporting the coin and backlit. Additional diffuse lighting is added from the side to bring up surface detail.

While this works well for black and white photography, in color work, the surface of the coin, because it is a mirror, will reflect the white of the diffuser rather than hold its true silver, gold or copper color. A better solution is to cut a hole large enough for the camera lens to see through in a board the same

"If slide duplicates are frequently required, self-contained slide duplicators are available."

color as the coin: silver, gold, or copper. Lights are then directed at the board, and the coin reflects the lighting on the board while retaining the correct surface color.

Photography of two-dimensional subjects can be carried out to the maximum available magnification of the camera/bellows/lens system, since there is no need to consider the effects of diminished depth of field as long as the system is carefully aligned to the subject.

Three-dimensional Subjects

The techniques covered so far in this book should cover the majority of lighting situations that would be required for close-up and macro photography in the studio. There are, however, a few specific subjects that present special problems and are worthy of further discussion. These include three-dimensional shiny objects and jewelry.

3-D Shiny Subjects

Whether dark or light, small, shiny, three-dimensional subjects present some real challenges. The shiny areas reflect the light source as a specular reflection and the rest of the studio, which is much darker than the light source, as black. What is desired is an even, shiny reflection over a large area that is not so bright that surface detail is obscured. This can be accomplished by constructing a tent around the subject, as shown on page 85.

The tent consists of translucent material, usually formed in the shape of a cylinder, lit from the outside. The walls of the tent become bright surfaces that the subject reflects, but the walls are so large relative to the subject that the highlight is spread completely over the surface and allows surface texture to be seen.

Lights can be set up on either side of the cylinder at 45 degrees, as if making a copy. One of the lights can be adjusted down in power to provide some modeling, or oftentimes only one light is required since the far side of the cylinder provides fill. If the subject is curved, the side with the light source will still exhibit a highlight, but it will be a diffuse one rather than specular reflection.

Jewelry

At first glance, it would seem that jewelry would be photographed in a tent. Sometimes it is, particularly for silver or platinum settings where the white light reflected off the cylinder walls has less of an effect in changing the color of the metal than the light has with gold. However, the biggest problem with tent lighting is its tendency to reflect white light off of the faceted surfaces of the precious stones, masking their color and, in the case of diamonds, their internal reflections.

"...the highlight is spread completely over the surface..."

Above: The leafy structure of this ornamental kale plant was photographed with a 200mm macro lens and a +2 diopter.

Below: The internal structure of natural objects will often provide an interesting study as in this photo of a section of kiwano fruit made entirely by transmitted light. An automatic TTL flash connected to the camera by an automated flash connecting cord (the "simple system" again) was placed beneath the slice of fruit as it lay on a piece of white Plexiglas to make the photo.

Above: At macro magnifications, subjects become studies in texture and form, as is seen in this image of an abalone shell.

Below: Photographing in the studio at high magnification, in this case about 2x, reveals intricate structures produced by nature that most people would never see. In this case, it is a tiny irregularity in an abalone shell.

Right: For photographing shiny subjects in the studio, a "tent" is the ideal solution. A temporary one, like the one shown here, can be easily made from a sheet of diffusing paper or plastic formed into a cylinder. Lights are arranged outside shining through to illuminate the subject.

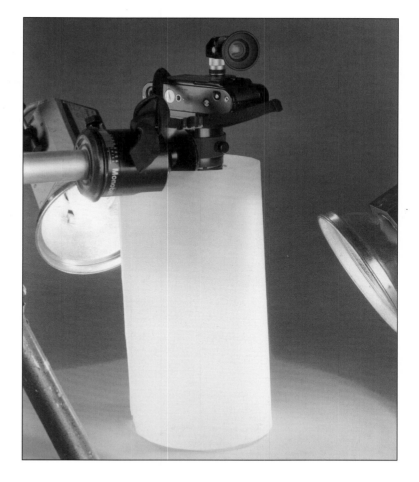

"Where accurate color rendition of the metal and stone is vital, Kodak EPY film should be used."

A better solution is to prop a diffusing screen opposite the camera at an angle from the surface the jewelry is lying on and to shine a spotlight through the diffuser. This type of backlight will provide a graduated reflection in the shiny upper surfaces of the subject. Gold or silver cards to the sides (depending on the jewelry), illuminated by spill light from the diffuser, will retain the proper metallic color in the resulting image.

With this method, the tables (upper surfaces) of the stones will still be reflecting the white diffuser and the character of the stones will be hidden. To eliminate this, small opaque pieces of paper can be taped to the surface of the diffuser to block the light falling on the top of the stones. Other dark cards can be set up to darken facets if desired. If the stone is a diamond, adding a fiber optic light set on low power and directed at the stone from a high angle close to the lens will provide internal reflections.

Where accurate color rendition of the metal and stone is vital, Kodak EPY film (ISO 64) should be used. It is balanced for 3200° Kelvin lights and designed for accurate reproduction of metallic colors.

Above and opposite page: Lighting the crystals inside of a geode at 1:1 is nearly impossible with conventional light sources. In this situation, a ringlight was used here and is the best lighting solution.

Conclusion

One very important part of marco and close up photography is analyzing results. Unfortunately, even among images that might be called "technically successful," there can be disappointments. Often, these images don't live up to their potential because the subject lacks one of the four visual requirements necessary to draw the eye to the intended element within the composition. Without the four requirements — color, value, sharpness and texture contrast — the primary subject can easily become lost in the overall composition.

Choosing either a subject or a camera position that maximizes the effect of color, value, sharpness and texture contrast is another of the various challenges faced in close-up and macro photography. This is true, for example, when photographing one of the myriad of small animals or insects that rely on camouflage (which is basically the lack of visual contrast) for survival. Anyone who's tried to shoot a camouflaged insect on a green leaf understands the need for color contrast.

Colors are most distinct when contrasted with their opposite: yellow against blue, magenta against green, red against blue-green, etc. Advertising images, which are designed for highest visual impact, use color contrast to the maximum. Models are posed in red outfits and yellow hats against blue-green tropical waters and deep blue skies. By isolating the subject against a contrasting colored background, the subject stands out, even to the casual viewer.

But it's not always easy, or even possible, to highlight the primary subject in a composition through contrasting colors. It's not that easy to shoot one red tulip in a field of other red tulips.

One approach might be to shoot from a different angle. Shooting low to isolate the red flower against the blue sky is a dramatic way of contrasting color.

Another possibility is to use value contrast to isolate the subject. Intentionally underexposing the surrounding flowers with the ambient light exposure, and then adding the correct amount of artificial light required for the specified f-stop being used will separate the primary tulip from its surroundings. The same effect can be accomplished by placing a dark fabric or mount board behind a subject, or using the two-flash system to reduce distracting backgrounds. In black and white, it's also possible to vary contrast and control composition through filters.

As magnification increases, sharpness contrast — the difference in sharpness between the subject and its surroundings —

automatically serves to isolate the subject and draw attention to it. That works even when there's no color or contrast value. At low magnifications, it's important to make sure that no other objects in the composition will be as sharp as the primary subject.

In this case, the choice of camera angle makes all the difference. While stopping the lens all the way down will generally ensure a sharply rendered subject, it can also lead to loss of sharpness contrast as background objects become more in focus. There has to be a balance in selecting the lens aperture. The lens has to be stopped down to the point that it will render the primary subject sharply in focus but not so far that it overly sharpens the background.

The fact that the background is out of focus doesn't ensure a successful image. If there's a strong pattern or dazzling highlights in the background, they can be very distracting. Whenever possible, it's best that the subject, rather than its surrounding, have the greatest texture. When distracting elements or highly textured backgrounds can't be avoided, camera angles or creating an artificial background come into play again to draw attention to the subject.

All in all, the success or failure of any close-up or macro photograph depends upon a myriad of factors, including the technical and artistic abilities of the photographer, the equipment available, the accessibility of the subject matter, and a variety of other factors. Any given subject matter can be photographed in any number of ways by any number of photographers. The important thing to remember is that, with close-up and macro photography, probably more than with any other type photographic specialty, success comes with practice.

To become successful, try the various equipment, lighting and shooting techniques again and again. Don't get discouraged when, at first, the photos don't come out just right. Once you've gained confidence in the basic techniques, experiment, try different approaches and use different equipment. Once you know the rules, don't let them hamper or restrict you. The most important thing is to realize your creative vision, and that can only be done with practice and patience.

"...success comes with practice."

Appendix

Studio Photography Session
Photographing a Crystal

Natural crystals can be one of the most interesting and challenging subjects for close-up and macro photography in the studio. Photography of crystals requires the technical ability to light the subject to show its faceting and structure while not overexposing areas. But it also requires aesthetic decisions about how you want the subject to be seen since an interpretation, rather than a scientific record, is expected. Deciding on a preliminary composition of the final image can often be done before the camera is even removed from its case.

Once a starting point is determined, the subject and camera are positioned. This apophylite with stilbite crystal was photographed at about 1/2-life size (0.5x) with a 100mm Micro-Nikkor mounted on a bellows attached to a Nikon F3, as shown in top photo on the opposite page. A small spring-loaded clamp held the subject in position, as shown in the bottom photo.

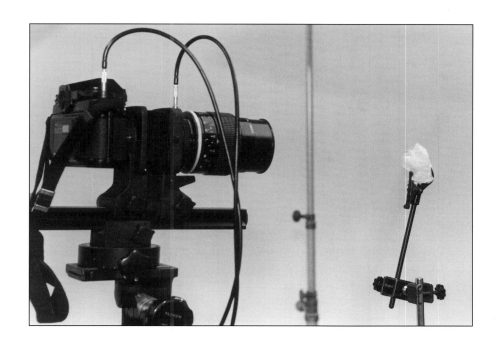

In order that that the reflections off the outer surfaces of the facets, which can act like mirrors, will not be over exposed, a fairly large light source relative to the size of the subject was chosen for lighting.

Various positions of the overhead light were tried (as shown in the photos on pages 93, 94 and 95) before the final position (see photo on page 96) was chosen. All of the light positions, as shown in the accompanying series of photos of the subject itself, produce different results. Choosing the final position is an aesthetic choice; there is no "wrong" unless the final image is not what was intended.

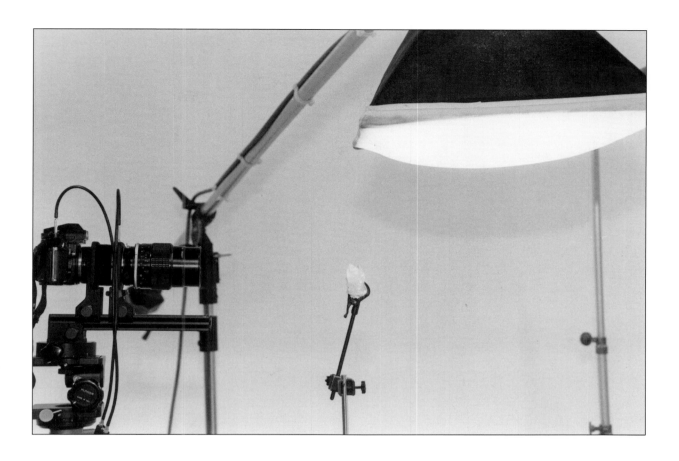

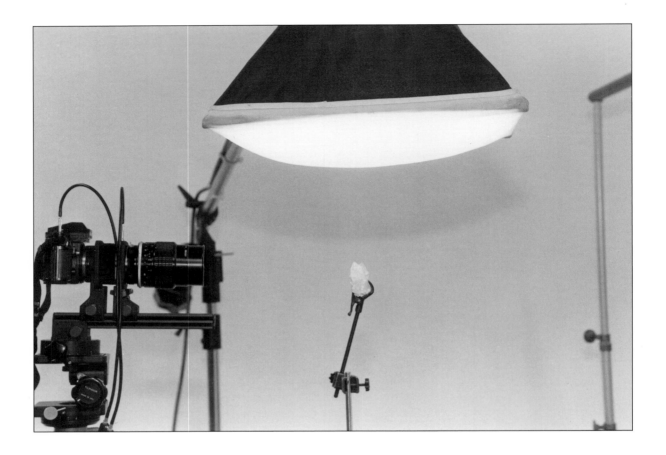

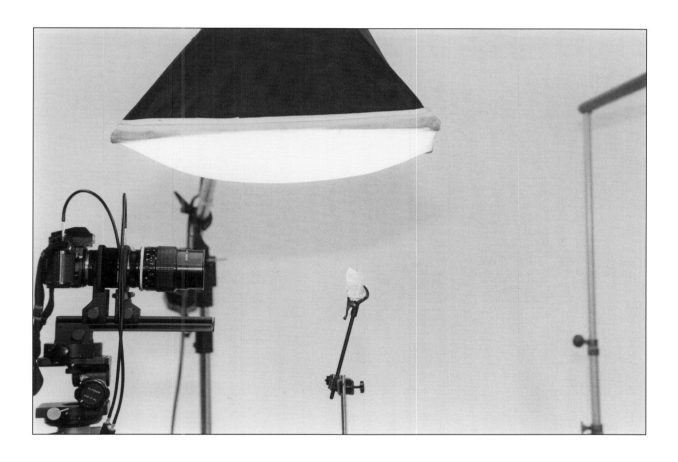

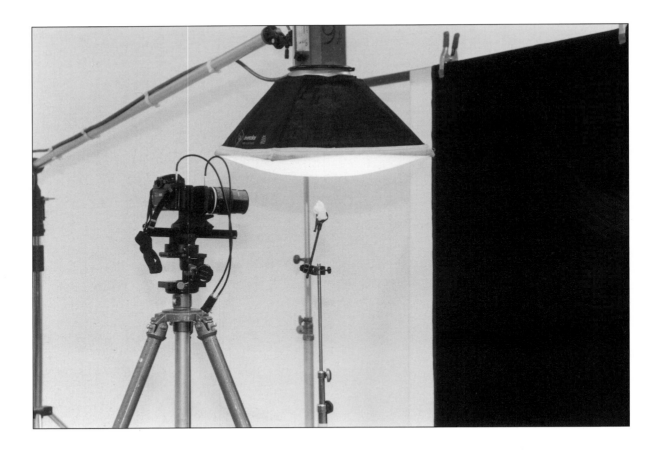

The final position for the main light, while showing off the faceting, didn't reveal enough of the internal structure, so a back-light was added as shown the photo below. This light was also moved around and its effect checked through the camera until the final position was selected.

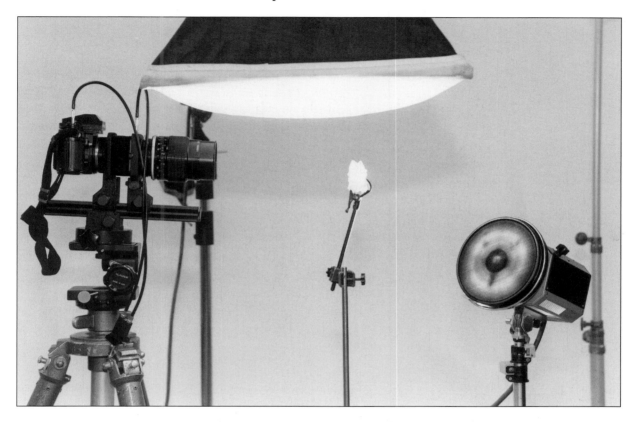

At this point, the crystal looked good, so flash meter readings were made and the power levels adjusted to set the exposure at $f/22$. This aperture is needed to give enough depth of field to keep the subject in good focus from front to back. The original idea was to photograph the crystal against a black velvet background, and a series of exposures at apertures around $f/22$ were made.

After these exposures were made, another light was set up to shine through a sheet of white Plexiglas behind the black velvet. This was done in an effort to add some depth to the photo, which seemed like it might be a bit two-dimensional and colorless. An adapter turned this light into a small spot, and a blue filter was positioned between it and the Plexiglas to add color (as shown in the photos on the opposite page and below). Using a flash meter, the level of this light was also adjusted to $f/22$.

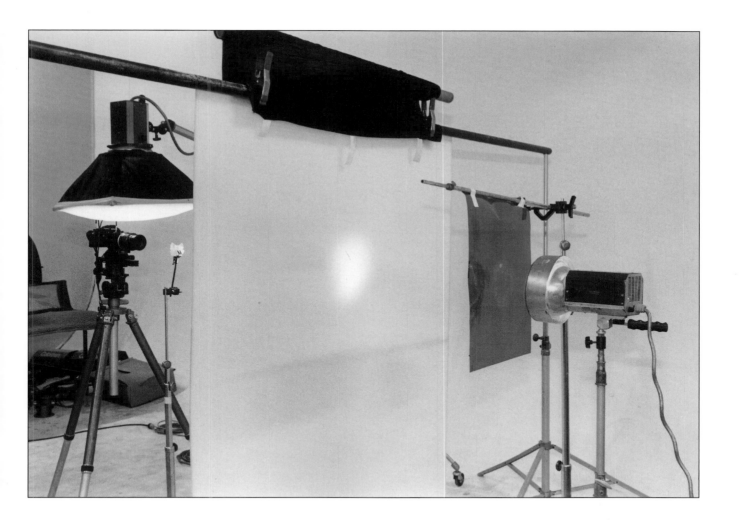

The final photo required a double exposure. One exposure was for the two foreground lights with the black velvet background (as shown in the photo below). This is the same photo that we had taken previously.

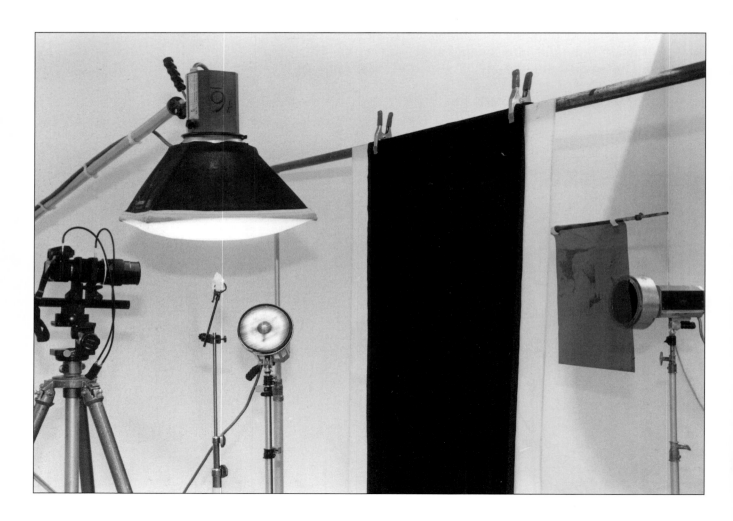

Then a second exposure was made on the same frame of film for the background light through the Plexiglas with the black velvet raised as shown below. The resulting photograph can be seen in the color plates.

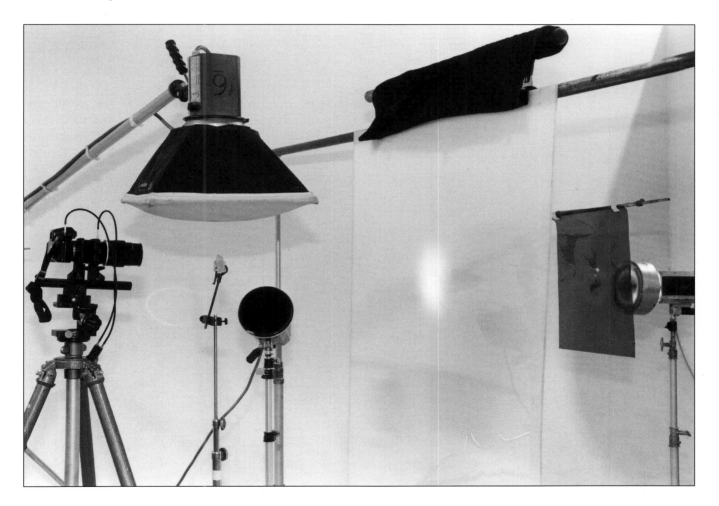

Glossary

Ambient light: The existing light falling on the subject to be photographed.

Ball head: A type of tripod head consisting generally of a ball held in a socket that can be loosened to adjust the position of the attached camera. Once loosened, movement is possible in all directions.

Bellows: Accordion-like accessory that attaches between the camera body and the lens to permit closer focusing than the lens alone can achieve. With a bellows, the range of magnification is continuous.

Bracketing: The practice of making several exposures at slightly different settings to ensure that the image captured on film is recorded as it was previsualized.

Close-up: The range of magnifications from 1/10 life-size (1/10x magnification or 1:10) to life-size (1x magnification or 1:1).

Close-up lens: An accessory lens attached to the front of the prime lens acting like a magnifying glass to allow closer focusing than the prime lens can achieve on its own.

Copy stand: A rigid column that attached to a solid base that holds the camera; used to make copies of flat documents.

Depth of field: The zone of sharpest focus in front of and behind the subject on which the lens is focused.

Diffuser: Any material placed between a light source and the subject to spread and soften the light. Common types are translucent plastics and artists' vellum.

Diopter: The reciprocal of the focal length in meters (1/focal length). A +2 diopter lens has a focal length of 1/2 meter or 500mm.

18 percent gray card: A standardized card that represents a middle value of gray. Reflected light meters are calibrated to record this value accurately.

Exposure factor: The amount of compensation that must be added to the reading from a hand-held exposure meter to account for the increased distance light must travel when the camera lens is extended away from the camera body in close-up and macro photography. Equal to the magnification plus one, the quantity squared. See page 48.

Extension tube: A hollow metal tube attached between the camera body and the lens to allow closer focusing than the lens alone can achieve. Available in different lengths that only provide certain magnifications.

***f*-number:** The numbers on the lens aperture ring that indicate the relative size of the fens opening. Indicated in this book as "*f*/8," "*f*/11," etc.

Fiber optics: Multiple strands of specially manufactured glass that transmit light with minimal loss of intensity. Available for macro photography to put light in very small areas.

Fill flash: A type of flash photography where the flash exposure is combined with the ambient light exposure, but at a lower level so as not to overpower the ambient exposure.

Focusing screen: The part of a camera where the image is formed for focusing. Some camera bodies allow the focusing screen to be removed and replaced with a different type. Matte groundglass or other specialized screens are best for higher-magnification macro photography.

Focusing stage: An accessory platform attached to the tripod head and supporting the camera and lens. The camera and lens are moved forward and back by micrometer drives to permit fine focusing rather than using the focusing ring on the lens, which changes the magnification when it is turned.

Gels: Colored sheets of translucent material used to change the color of a light source.

Guide number: A measure of flash output. The product of the distance from the flash to the subject times the f-number needed for correct exposure.

Highlights: Those areas of a scene that are bright but still retain some detail. See Specular highlights.

ISO number: The international standard for comparing film sensitivity to light. The higher the number, the more sensitive.

Latitude: The range of image contrast that a film can record. Transparency film has a range of at least five f-stops and color negative film considerably more.

Macro: The range of magnifications from life-size (1x magnification or 1:1) to 40-times life-size (40x magnification or 40:1). Technically, the term for photography in this range is "photomacrography."

Magnification: The ration of the size of the final image to the size of the subject.

Mid-tones: The areas of a scene between highlights and shadows.

Mirror lock-up: The ability of a camera body to lock its mirror in the "up" position before making an exposure to minimize vibration.

Modeling light: In AC-powered studio strobes, a light that is continually on to approximate the light that the flashtube will produce.

Pentaprism: The portion of the camera between the eyepiece and the focusing screen, consisting of mirror surfaces that produces an upright image. The pentaprism of some cameras is removable to allow accessory viewfinders for macro photography to be attached.

Photomacrography: Photography in the range of magnifications from life-size (1x magnification or 1:1) to 40-times life-size (40x magnification or 40:1). See Macro.

Photomicrography: Photography through a microscope with a range of magnifications generally greater than 20-times life-size (20x magnification of 20:1).

Platform head: A type of tripod head consisting of a camera platform controlled by several locking arms that allow adjustments to be made in different planes one by one.

Polarizing filter: A type of filter that can be rotated to eliminate reflections or to enhance the blue of the sky.

Previsualization: Forming an image in the mind of the way the finished photograph will look, including the composition, exposure, focus, sharpness, etc.

Pupillary magnification: The ratio of the size of the lens diaphragm when measured through the front of the lens to the size measured through the back of the lens. Must be taken into account when calculating the exposure factor for a given magnification. See Exposure factor.

Quick-release: A system consisting of two plates, one attached to the tripod socket of the camera, and the other attached to the tripod head (either ball head or platform head).

Reflector: Any object that is used to reflect light onto the subject. Most common are mirrors, white cards, silver cards and gold cards.

Reversing ring: A thin metal ring which attaches to the front of a camera lens and has a mount on the other side that attaches to the camera body.

Shadows: The dark areas of a scene where there is still detail.

Specular highlights: The brightest areas in a scene that contain no detail, such as the reflection of the sun in a drop of water or off a metallic surface.

Stop-down metering: A method of determining ambient light exposure where the lens must be closed down manually in order for the camera body to determine the appropriate shutter speed. Often needed when using a bellows or a reversing ring.

Tent: A way to produce diffuse lighting. The subject is surrounded by diffusing material and light is shined through the material onto the subject.

Through-the-lens metering: The ability of a camera's built-in meter to make an exposure reading through the camera's lens of the actual scene that will be photographed.

Tripod socket: A connection on the bottom of a camera that permits a tripod or quick-release plate to be attached. For macro photography, the tripod socket should be directly beneath the lens.

Index

Other Books from
Amherst Media, Inc.

Basic 35mm Photo Guide

Craig Alesse

Great for beginning photographers! Designed to teach 35mm basics step-by-step — completely illustrated. Features the latest cameras. Includes: 35mm automatic, semi-automatic cameras, camera handling, *f*-stops, shutter speeds, and more! $12.95 list, 9x8, 112p, 178 photos, order no. 1051.

Build Your Own Home Darkroom

Lista Duren & Will McDonald

This classic book teaches you how to build a high quality, inexpensive darkroom in your basement, spare room, or almost anywhere. Includes valuable information on: darkroom design, woodworking, tools, and more! $17.95 list, 8½x11, 160p, order no. 1092.

Into Your Darkroom Step-by-Step

Dennis P. Curtin

This is the ideal beginning darkroom guide. Easy to follow and fully illustrated each step of the way. Includes information on: the equipment you'll need, set-up, making proof sheets and much more! $17.95 list, 8½x11, 90p, hundreds of photos, order no. 1093.

Wedding Photographer's Handbook

Robert and Sheila Hurth

A complete step-by-step guide to succeeding in the world of wedding photography. Packed with shooting tips, equipment lists, must-get photo lists, business strategies, and much more! $24.95 list, 8½x11, 176p, index, b&w and color photos, diagrams, order no. 1485.

Lighting for People Photography, 2nd ed.

Stephen Crain

The up-to-date guide to lighting. Includes: set-ups, equipment information, strobe and natural lighting, and much more! Features diagrams, illustrations, and exercises for practicing the techniques discussed in each chapter. $29.95 list, 8½x11, 120p, b&w and color photos, glossary, index, order no. 1296.

Camera Maintenance & Repair **Book 1**

Thomas Tomosy

A step-by-step, illustrated guide by a master camera repair technician. Includes: testing camera functions, general maintenance, basic tools needed and where to get them, basic repairs for accessories, camera electronics, plus "quick tips" for maintenance and more! $29.95 list, 8½x11, 176p, order no. 1158.

Camera Maintenance & Repair **Book 2**

Thomas Tomosy

Build on the basics covered Book 1, with advanced techniques. Includes: mechanical and electronic SLRs, zoom lenses, medium format cameras, and more. Features models not included in the Book 1. $29.95 list, 8½x11, 176p, 150+ photos, charts, tables, appendices, index, glossary, order no. 1558.

Restoring the Great Collectible Cameras (1945-70)

Thomas Tomosy

More step-by-step instruction on how to repair collectible cameras. Covers postwar models (1945-70). Hundreds of illustrations show disassembly and repair. $29.95 list, 8½x11, 128p, 200+ photos, index, order no. 1560.

Big Bucks Selling Your Photography

Cliff Hollenbeck

A complete photo business package. Includes secrets for starting up, getting paid the right and creating successful portfolios! Features financial, marketing and creative goals. C your business planning, bookkeeping, a $15.95 list, 6x9, 336p, order no. 1177.

Outdoor and Locat Portrait Photograph

Jeff Smith

Learn how to work with natural locations, and make clients look the by-step discussions and helpful illus you the techniques you need to s portraits like a pro! $29.95 list, 8 b&w and color photos, index, order

Make Money with Your Camera

David Neil Arndt

Learn everything you need to know in order to make money in photography! David Arndt shows how to take highly marketable pictures, then promote, price and sell them. Includes all major fields of photography. $29.95 list, 8½x11, 120p, 100 b&w photos, index, order no. 1639.

Leica Camera Repair Handbook

Thomas Tomosy

A detailed technical manual for repairing Leica cameras. Each model is discussed individually with step-by-step instructions. Exhaustive photographic illustration ensures that every step of the process is easy to follow. $39.95 list, 8½x11, 128p, 130 b&w photos, appendix, order no. 1641.

Guide to International Photographic Competitions

Dr. Charles Benton

Remove the mystery from international competitions with all the information you need to select competitions, enter your work, and use your results for continued improvement and further success! $29.95 list, 8½x11, 120p, b&w photos, index, appendices, order no. 1642.

Freelance Photographer's Handbook

Cliff & Nancy Hollenbeck

Whether you want to be a freelance photographer or are looking for tips to improve your current freelance business, this volume is packed with ideas for creating and maintaining a successful freelance business. $29.95 list, 8½x11, 107p, 100 b&w and color photos, index, glossary, order no. 1633.

Infrared Landscape Photography

Todd Damiano

Landscapes shot with infrared can become breathtaking and ghostly images. The author analyzes over fifty of his most compelling photographs to teach you the techniques you need to capture landscapes with infrared. $29.95 list, 8½x11, 120p, b&w photos, index, order no. 1636.

Wedding Photography: Creative Techniques for Lighting and Posing

Rick Ferro

Creative techniques for lighting and posing wedding portraits that will set your work apart from the competition. Covers every phase of wedding photography. $29.95 list, 8½x11, 128p, b&w and color photos, index, order no. 1649.

Professional Secrets of Advertising Photography

Paul Markow

No-nonsense information for those interested in the business of advertising photography. Includes: how to catch the attention of art directors, make the best bid, and produce the high-quality images your clients demand. $29.95 list, 8½x11, 128p, 80 photos, index, order no. 1638.

Lighting Techniques for Photographers

Norman Kerr

This book teaches you to predict the effects of light in the final image. It covers the interplay of light qualities, as well as color compensation and manipulation of light and shadow. $29.95 list, 8½x11, 120p, 150+ color and b&w photos, index, order no. 1564.

Infrared Photography Handbook

Laurie White

Covers black and white infrared photography: focus, lenses, film loading, film speed rating, batch testing, paper stocks, and filters. Black & white photos illustrate how IR film reacts. $29.95 list, 8½x11, 104p, 50 b&w photos, charts & diagrams, order no. 1419.

Infrared Nude Photography

Joseph Paduano

A stunning collection of images with how-to text that teaches how to shoot the infrared nude. Shot on location in natural settings, including the Grand Canyon, Bryce Canyon and the New Jersey Shore. $29.95 list, 8½x11, 96p, over 50 photos, order no. 1080.

How to Shoot and Sell Sports Photography

David Arndt

A step-by-step guide for amateur photographers, photojournalism students and journalists seeking to develop the skills and knowledge necessary for success in the demanding field of sports photography. $29.95 list, 8½x11, 120p, 111 photos, index, order no. 1631.

How to Operate a Successful Photo Portrait Studio

John Giolas

Combines photographic techniques with practical business information to create a complete guide book for anyone interested in developing a portrait photography business (or improving an existing business). $29.95 list, 8½x11, 120p, 120 photos, index, order no. 1579.

Black & White Landscape Photography

John Collett and David Collett

Master the art of b&w landscape photography. Includes: selecting equipment (cameras, lenses, filters, etc.) for landscape photography, shooting in the field, using the Zone System, and printing your images for professional results. $29.95 list, 8½x11, 128p, order no. 1654.

Creative Techniques for Nude Photography

Christopher Grey

Create dramatic fine art portraits of the human figure in black & white. Features studio techniques for posing, lighting, working with models, creative props and backdrops. Also includes ideas for shooting outdoors. $29.95 list, 8½x11, 128p, order no. 1655.

Wedding Photojournalism

Andy Marcus

Learn the art of creating dramatic unposed wedding portraits. Working through the wedding from start to finish you'll learn where to be, what to look for and how to capture it on film. A hot technique for contemporary wedding albums! $29.95 list, 8½x11, 128p, order no. 1656.

Studio Portrait Photography of Children and Babies

Marilyn Sholin

Learn to work with the youngest portrait clients to create images that will be treasured for years to come. Includes tips for working with kids at every developmental stage, from infant to pre-schooler. Features: lighting, posing and much more! $29.95 list, 8½x11, 128p, order no. 1657.

Professional Secrets of Wedding Photography

Douglas Allen Box

Over fifty top-quality portraits are individually analyzed to teach you the art of professional wedding portraiture. Lighting diagrams, posing information and technical specs are included for every image. $29.95 list, 8½x11, 128p, order no. 1658.

Photographer's Guide to Shooting Model & Actor Portfolios

CJ Elfont, Edna Elfont and Alan Lowy

Learn to create outstanding images for actors and models looking for work in fashion, theater, television, or the big screen. Includes the business, photographic and professional information you need to succeed! $29.95 list, 8½x11, 128p, order no. 1659.

Photo Retouching with Adobe® Photoshop®

Gwen Lute

Designed for photographers, this manual teaches every phase of the process, from scanning to final output. Learn to restore damaged photos, correct imperfections, create realistic composite images and correct for dazzling color. $29.95 list, 8½x11, 120p, order no. 1660.

Creative Lighting Techniques for Studio Photographers

Dave Montizambert

Master studio lighting and gain complete creative control over your images. Whether you are shooting portraits, cars, table-top or any other subject, Dave Montizambert teaches you the skills you need to confidently create with light. $29.95 list, 8½x11, 120p, order no. 1666.

Storytelling Wedding Photography

Barbara Box

Barbara and her husband shoot as a team at weddings. Here, she shows you how to create outstanding candids (which are her specialty), and combine them with formal portraits (her husband's specialty) to create a unique wedding album. $29.95 list, 8½x11, 128p, order no. 1667.

Fine Art Children's Photography

Doris Carol Doyle and Ian Doyle

Learn to create fine art portraits of children in black & white. Included is information on: posing, lighting for studio portraits, shooting on location, clothing selection, working with kids and parents, and much more! $29.95 list, 8½x11, 128p, order no. 1668.

Infrared Portrait Photography

Richard Beitzel

Discover the unique beauty of infrared p and learn to create them yourself. In information on: shooting with infrared subjects and settings, filtration, lighting, more! $29.95 list, 8½x11, 128p, order

Black & White Photography for 35

Richard Mizdal

A guide to shooting and darkroom Perfect for beginning or interme graphers who wants to improve Features helpful illustrations and exe every concept clear and easy to follo 8½x11, 128p, order no. 1670.

Secrets of Successful Aerial Photography

Richard Eller

Learn how to plan for every aspect of a shoot and take the best possible images from the air. Discover how to control camera movement, compensate for environmental conditions and compose outstanding aerial images. $29.95 list, 8½x11, 120p, order no. 1679.

Professional Secrets of Nature Photography

Judy Holmes

Improve your nature photography with this must-have, full color book. Covers every aspect of making top-quality images, from selecting the right equipment, to choosing the best subjects, to shooting techniques for professional results every time.$29.95 list, 8½x11, 120p, order no. 1682.

Macro and Close-up Photography Handbook

Stan Sholik

Learn to get close and capture breathtaking images of small subjects – flowers, stamps, jewelry, insects, etc. Designed with the 35mm shooter in mind, this is a comprehensive manual full of step-by-step techniques. $29.95 list, 8½x11, 120p, order no. 1686.

Photographing Children in Black & White

Helen T. Boursier

Learn the techniques professionals use to capture classic portraits of children (of all ages) in black & white. Discover posing, shooting, lighting and marketing techniques for black & white portraiture in the studio or on location. $29.95 list, 8½x11, 128p, order no. 1676.

Marketing and Selling Black & White Portrait Photography

Helen T. Boursier

A complete manual for adding b&w portraits to the products you offer clients (or offering exclusively b&w photography). Learn how to attract clients and deliver the portraits that will keep them coming back. $29.95 list, 8½x11, 128p, order no. 1677.

Outdoor and Survival Skills for Nature Photographers

Ralph LaPlant and Amy Sharpe

An essential guide for photographing outdoors. Learn all the skills you need to have a safe and productive shoot – from selecting equipment, to finding subjects, to preventing (or dealing with) injury and accidents. $17.95 list, 8½x11, 80p, order no. 1678.

Art and Science of Butterfly Photography

William Folsom

Learn to understand and predict butterfly behavior (including feeding, mating and migrational patterns), when to photograph them and even how to lure butterflies. Then discover the photographic techniques for capturing breathtaking images of these colorful creatures. $29.95 list, 8½x11, 120p, order no. 1680.

Infrared Wedding Photography

Patrick Rice, Barbara Rice & Travis Hill

Step-by-step techniques for adding the dreamy look of black & white infrared to your wedding portraiture. Capture the fantasy of the wedding with unique ethereal portraits your clients will love! $29.95 list, 8½x11, 128p, order no. 1681.

Practical Manual of Captive Animal Photography

Michael Havelin

Learn the environmental and preservational advantages of photographing animals in captivity – as well as how to take dazzling, natural-looking photos of captive subjects (in zoos, preserves, aquariums, etc.). $29.95 list, 8½x11, 120p, order no. 1683.

Composition Techniques from a Master Photographer

Ernst Wildi

In photography, composition can make the difference between dull and dazzling. Master photographer Ernst Wildi teaches you his techniques for evaluating subjects and composing powerful images in this beautiful full color book. $29.95 list, 8½x11, 128p, order no. 1685.

Innovative Techniques for Wedding Photography

David Neil Arndt

Spice up your wedding photography (and attract new clients) with dozens of creative techniques from top-notch professional wedding photographers! $29.95 list, 8½x11, 120p, order no. 1684.

Dramatic Black & White Photography:
Shooting and Darkroom Techniques

J.D. Hayward

Create dramatic fine-art images and portraits with the master b&w techniques in this book. From outstanding lighting techniques to top-notch, creative darkroom work, this book takes b&w to the next level! $29.95 list, 8½x11, 128p, order no. 1687.

Photographing Your Artwork

Russell Hart

A step-by-step guide for taking high-quality slides of artwork for submission to galleries, magazines, grant committees, etc. Learn the best photographic techniques to make your artwork (be it 2D or 3D) look its very best! $29.95 list, 8½x11, 128p, order no. 1688.

Posing and Lighting Techniques for Studio Photographers

J.J. Allen

Master the skills you need to create beautiful lighting for portraits of any subject. Posing techniques for flattering, classic images help turn every portrait into a work of art. $29.95 list, 8½x11, 120p, order no. 1697.

Studio Portrait Photography in Black & White

David Derex

From concept to presentation, you'll learn how to select clothes, create beautiful lighting, prop and pose top-quality black & white portraits in the studio. $29.95 list, 8½x11, 128p, order no. 1689.

Watercolor Portrait Photography: The Art of Manipulating Polaroid SX-70 Images

Helen T. Boursier

Create one-of-a-kind images with this surprisingly easy artistic technique. $29.95 list, 8½x11, 120p, order no. 1698.

Techniques for Black & White Photography: Creativity and Design

Roger Fremier

Harness your creatvity and improve your photographic design with these techniques and exercises. From shooting to editing your results, it's a complete course for photographers who want to be more creative. $19.95 list, 8½x11, 112p, order no. 1699.

Corrective Lighting and Posing Techniques for Portrait Photographers

Jeff Smith

Learn to make every client look his or her best by using lighting and posing to conceal real or imagined flaws – from baldness, to acne, to figure flaws. $29.95 list, 8½x11, 120p, order no. 1701.

How to Buy and Sell Used Cameras

David Neil Arndt

Learn the skills you need to evaluate the cosmetic and mechanical condition of used cameras, and buy or sell them for the best price possible. Also learn the best places to buy/sell and how to find the equipment you want. $19.95 list, 8½x11, 112p, order no. 1702.

Basic Digital Photography

Ron Eggers

Step-by-step text and clear explanations teach you how to select and use all types of digital cameras. Learn all the basics with no-nonsense, easy to follow text designed to bring even true novices up to speed quickly and easily. $17.95 list, 8½x11, 80p, order no. 1703.

Make-Up Techniques for Photography

Cliff Hollenbeck

Step-by-step text paired with photographic illustrations teach you the art of photographic make-up. Learn to make every portrait subject look his or her best with great styling techniques for black & white or color photography. $29.95 list, 8½x11, 120p, order no. 1704.

More Photo Books Are Available!

Write or fax for a *FREE* catalog:

Amherst Media
PO Box 586
Amherst, NY 14226 USA

Fax: 716-874-4508

www.AmherstMediaInc.com

Ordering & Sales Information:

INDIVIDUALS: If possible, purchase books from an Amherst Media retailer. Write to us for the dealer nearest you. To order direct, send a check or money order with a note listing the books you want and your shipping address. U.S. & overseas freight charges are $3 for first book and $1.00 for each additional book. Visa and Master Card accepted. New York state residents add 8% sales tax.

DEALERS, DISTRIBUTORS & COLLEGES: Write, call or fax to place orders. For price information, contact Amherst Media or an Amherst Media sales representative. Net 30 days.

All prices, publication dates, and specifications are subject to change without notice.

Prices are in U.S. dollars. Payment in U.S. funds only.